The Art & Craft of

BLACK

&

WHITE

PHOTOGRAPHY

The Art & Craft of

BLACK
&
WHITE

PHOTOGRAPHY

George Schaub

NTC Publishing Group
Lincolnwood, Illinois USA

Cover and book design: Rick Dinihanian & John Lyle, Green Lizard Design

Library of Congress Cataloging-in-Publication Data

Schaub, George.
 The art and craft of black-and-white photography / George Schaub.
 p. cm
 Includes index.
 ISBN 0-8442-5799-0 (softbound)
 1. Photography—Amateurs' manuals. I. Title.
TR146.S33 1996
771—dc20 96–12466
 CIP

Published by NTC Publishing Group
© 1997 NTC Publishing Group, 4255 West Touhy Avenue
Lincolnwood (Chicago), Illinois 60646-1975 U.S.A.

Manufactured in the United States of America.

6 7 8 9 0 QB 9 8 7 6 5 4 3 2 1

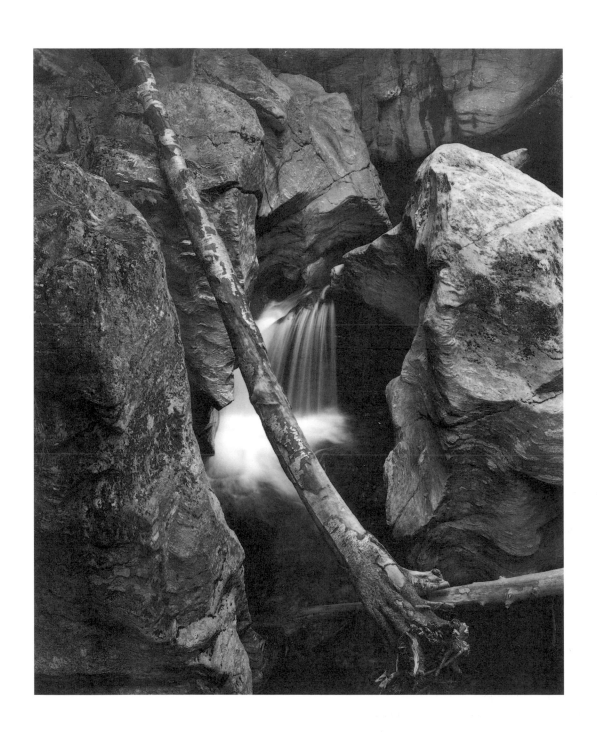

CONTENTS

Chapter 4

 This book is written for the students, artists, and photographers who have been touched by the magic of black-and-white photography and for those who are intrigued by its creative possibilities. The format and style are based upon the concept that photography is an accessible visual medium and that gaining an understanding of the fundamentals does not require one to become involved in scientific charts and chemical formulas. This book is also based upon the notion that the image comes first and that technique exists to serve the creative expression of the individual photographer.

The organization of the book reflects two premises: that there are a number of steps necessary to learn the craft and that there are stages to go through before that craft can become an expression of art. First, there is the need to gain an appreciation of the medium. This involves learning the semantics of black and white and gaining an understanding of its history. Next, there is a need to consider the tools and how to use them. Indeed, failure to do so would waste both time and materials.

The tools of the craft—chemicals, film, printing papers, enlargers, and so forth—are not complex, but they do

demand proper use. The proper use of the tools is called *craft*; the application of that craft is called *technique*. The assumption is that the sole purpose of technique is to serve the vision of the photographer and that technique is not an end in itself. Experience has shown me that lack of technique will do more to block vision than any imagined internal demons.

Technique is also the knowledgeable application of the principles of photography to its practice. Film exposure, film developing, and printing technique do have rules that, when followed, make the work relatively easy. These are not rules put into effect by academics or pedants to stunt expression or creativity. Rather, they are rules dealing with how to mix chemicals, how to add a feathering touch of light to the edge of prints, how to lower contrast during development, and so forth. When understood and implemented, these rules augment the creative aspects of this craft.

Once technique is understood, the door to creativity is opened, if but a crack. The process of translating feelings and perceptions to negatives and prints involves combining technique with personal commitment and vision. In essence, the tools and the technique are the

foundation on which the creative aspects of photography are built. Thus the title *The Art and Craft of Black-and-White Photography*.

The book begins with a discussion of the aesthetics of black and white and an appreciation of the power of the black-and-white image. It explores ways to understand the creative possibilities offered by the medium and gives some grounding in terminology.

This is followed by a brief synopsis of the development and history of the craft, chiefly through the ways in which people sought to make images. The text does not pretend to be a concise and detailed history of photography—there are many worthy books dedicated solely to that subject. Instead, the aim is to give an outline of the road traveled toward today's technology, as well as a foundation of history on which the reader can build an understanding of modern tools and practices.

We then explore the basic practices of black-and-white photography. Extensive discussion is devoted to film, exposure, chemical processing, printing controls, materials, and so forth. We then look into extensions of these practices, including advanced techniques, special effects, and alternative forms of photographic expression.

It is hoped that the study of black and white will encourage you to learn more about photographic history, about technical areas such as optics and chemistry, and about the images and the photographers that have shaped our cultural heritage. It is also hoped that your photography will lead you to meet as many interesting people and visit as many fascinating places as I have had the pleasure to enjoy.

You may find that photography is a vehicle both for expression and for experiencing life. Perhaps photography may become the means by which you earn a living. Though much of this work may be done in creative and often self-imposed isolation, there is a strong sense of fraternity among those who meet its challenge and enjoy its rewards.

The aim of this book, then, is to encourage you to think about the potential of this unique visual medium and to give you a strong foundation in the practice of the craft.

GEORGE SCHAUB

Chapter 1

AN APPRECIATION
OF BLACK-AND-WHITE
PHOTOGRAPHY

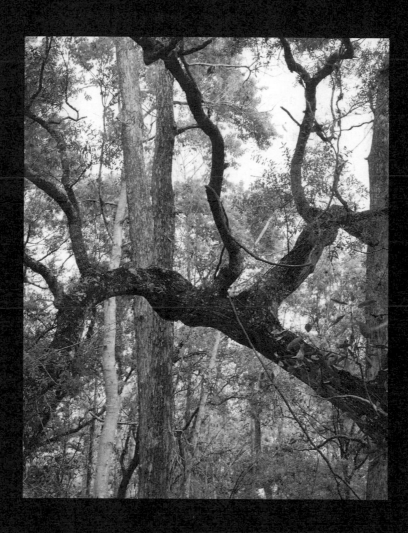

AN APPRECIATION OF BLACK-AND-WHITE PHOTOGRAPHY

 What is it about black-and-white photography that makes it such a compelling visual medium? In terms of pure visual enjoyment, there is the beauty of the tonal values—the shades of gray and deep blacks and bright whites—that express the play of light and shadow. The tones are versatile and can convey a stark or subtle ambiance with equal power. Black and white also allows us to see without the distraction of color. Often, this means that we can approach the heart of a matter, or of a design, in its purest form. For the photographer, black and white offers a great deal of creative freedom. The artistic intent of the photographer can be involved in every step of the creation of the image—from choice of subject to exposure, film processing, and printing.

When color became available on a mass scale in the middle of the twentieth century, there were those who claimed that black and white was a medium whose time had passed. For the snapshot photographer and mass-market photography, this was mostly true. But the dedication to black and

Black-and-white photography offers a wide range of interpretations that allows the photographer to make creative choices at practically every step of the imaging process. Expressive decisions can alter the mood or message of virtually every print. Here, two interpretations from the same negative reflect a "high key" rendition (above), which emphasizes lighter tones, and a "low key" rendition (left), which plays more on shadows and lower tones. This choice is available when prints are made, but variations in film, exposure, and development procedures can affect the final image as well. (Photos: Grace Schaub.)

Most people identify black and white as the medium for old family photos or as the visual storyteller of a period in history stretching from the 1840s through the 1950s. While this association is strong, black and white is also an eminently modern medium that allows for the greatest graphic, abstract, and, for some, emotional communication of any photographic form.

white among artistic, fashion, journalistic, and, increasingly, commercial photographers continues to grow.

To those engaged in a serious study of and love for photography, black and white is of great importance. To those who collect photography, it is the medium of choice. And, as color electronic and computer imaging take over more and more of the snapshot and commercial imaging tasks, black and white will be the essential expression—perhaps the only expression—of silver-based imaging.

All photography, whether color or black and white, is an abstraction and an illusion. The heart of the abstraction is in the representation of a three-dimensional world in a two-dimensional space—the print. The illusion is in the formation of an image from millions of microscopic silver clumps, or grains. We have all come to accept the

reality represented by the photographic print. The image formed creates a chain of associations that evokes people, places, feelings, or events.

Black-and-white images are particularly evocative and hold a special place in the cultural and social history of the past one hundred and sixty years. Black-and-white photographic images bring forth a range of feelings, from the nostalgia we feel when viewing old family photos or classic black-and-white movies to reverence for history preserved in news photos and portraits that have become icons of their age. Even with these old associations, however, we see black and white as a very modern photographic medium as well, as it communicates abstraction with ease through its monochromatic rendering of a colorful world.

This ability to express and communicate a wide range of feelings is what makes black and white such a fascinating medium in which to work. While it is in many ways a free form that encourages interpretation and variation, it also is a discipline that takes study and effort to master. It is accessible, yet when explored deeply, it is as challenging as any visual form of art.

COLOR AND BLACK AND WHITE

When photography was first widely practiced, there were those who immediately sought ways to make color images, or who insisted that color be added through paints, toners, or dyes. It is often surprising to

see just how much color was daubed onto nineteenth-century images, like first learning that many ancient Roman or Greek statues were painted, and often gaudily at that. The images of the nineteenth century, including calling cards with pictures dubbed Carte de Visite, natural scenics and contrived assemblages, were dutifully colored by freelance artists and painters employed by photographic studios. Understandably, the lack of color often bothered these photographers, as it did the consumers who wanted a natural portrayal of themselves or their loved ones. If not colored, the prints were toned, sometimes in imitation of paintings and other times to remove the cold, metallic rendition of the photographic image itself.

We look at these images as quaint, but only because today we have the ability to choose between a color and a black-and-white image. And because color is with us in every format, speed, and saturation, the black-and-white image serves as a unique visual form that need not stand in as the base for colorized images. Indeed, when we choose to color a black-and-white image or to tone it in some way, we do so to add to its expressive qualities—not merely to make up for lack of color.

Black-and-white and color photography share many of the same principles and practices; in fact, every color image begins as a silver image prior to that silver being exchanged for color dyes. But there are certainly points of departure in the study and appreciation of black and white and color. This does not mean that it's a color versus black and white debate, however. There are no sides to be chosen and defended. Rather, it's more a matter of appreciating the artistic pleasure that black and white affords and understanding the visual dynamics that make it unique.

The Art and the Craft

The combination of art (seeking to evoke response and to communicate ideas and feelings through creativity) and craft (the techniques that make for effective art) is delicately balanced in every stage of creating a black-and-white image. The aim is to create images that will touch the viewer and serve as expressive vehicles for the photographer.

While technique is important and is the focus of much of our discussion throughout this book, it is there only to serve the expression, or the art. How something is done should not overwhelm why it is done. The vision of the photographer, and the image created from that vision, are always most important. Technical matters are the foundation of the craft—revelation and an appreciation of the power of the medium in which you're working are what will create the art.

To document a moment is one aim. To create an image that reaches into another's eye, brain, and heart is another. Images can stun, inform, amuse, or even anger a viewer. The way in which the photographer approaches the creation of the image and the techniques used to realize it have a profound effect on the success

The faithful recording of moments in time is the aim of most photographers, but it is in the refinement of images that the art of photography is practiced. This refinement usually occurs in the darkroom, well after the original image has been captured on film. There, the printer may reinterpret the original image (above left) to idealize the light or mood, to add a more graphic approach to an image (above right), or to eliminate some parts of the scene altogether. Each choice conveys a unique message by emphasizing different plays of light and shadow.

of the communication between the photographer, who seeks to touch without words, and the viewer.

Photographs give information and spark emotions. These functions are not necessarily separate. Indeed, there are studies that indicate that the main function of the brain is to create images shaped by the senses in a way that can be applied in the real world. What better extension of the mind's eye, then, than the camera, and what better way to communicate on many levels to other humans than with pictures.

Photography is seeing and feeling (or sensing and analyzing), then translating those impressions and thoughts into photographic terms using various techniques of the craft. The aim is to open your eyes to the world around you, to interpret what you see, and to share those perceptions with others.

As you photograph and print, images form associations and vision takes on definition. Then, as vision becomes refined by and manifested through a mastery of technique, the art and craft of photography blend.

THE BLACK-AND-WHITE PRINT

The end product of creating black-and-white images is the print, whether it is seen in a book or magazine, on a gallery wall, or held in the hand. A successful print communicates the thoughts and feelings of the photographer at the moment the shutter is snapped; often, it is a faithful rendition of the quality of light that appeared in the original scene.

However, most prints are refinements of the moment, or even reinterpretations of the scene. Refinements are made in order to enhance the image or to add further visual expression; reinterpretations are the photographer's exploration of the visual possibilities of the image, beyond what was glimpsed or intuited when the shutter was first released.

The ability to refine or reinterpret the vision is one of the most exciting aspects of the art and craft of photography. The artistic freedom this brings is key to the ability to communicate photographically.

In many cases, the aim of the print is to involve the viewer on an emotional, spiritual, intellectual, or even commercial level. The print can inform or confuse, educate or obfuscate. Whatever the motivation of the photographer, the print should catch the eye. Printing technique is one of the keys to making this happen.

The Photographer as Printmaker

Ideally, the photographer will also prepare the print. Black and white requires involvement—it is not like snapshot photography, in which clicking the shutter marks the end of the photography process. In fact, if the photographer fails to become involved in the processing of film and in printmaking, much of the character of the image—and certainly most of the fun and excitement of the work—will be lost.

This doesn't mean, however, that you can't use the services of competent laboratories to handle your film and prints. You must recognize, though, that doing so results in your giving up some control and much of the potential for artistic expression in the medium. In short, creativity in this medium is based not only upon the vision of the photographer, but also on the ability to translate that vision through applied techniques after the picture is taken. If you involve outside labs, you must communicate your needs very carefully to the technicians handling your work. Failure to do so generally brings disappointing results.

This thinking is not meant to imply a snobbish approach to the work. It is a point of view based upon the author's years of experience as both a professional photographer and a custom printer in a commercial photographic lab. Admittedly, there are some fairly mechanical aspects to the craft, but failure to apply these practices in a consistent manner (a danger when dealing with outside labs) can have a profound effect on results. For this reason, even if you will be taking your work to a lab, you should still have a strong understanding of processing and printing techniques. This background will enable you to communicate on a professional level with the technicians and will usually result in better work and greater satisfaction.

VISUAL LITERACY

Just as those who would be writers must read the great books, photographers should study both the classical and contemporary work of colleagues. It is important to appreciate the inherent power of the black-and-white medium and to recognize and understand the terms and visual associations that make it work.

Begin by looking at prints, regardless of who may have created them. Study prints that touch you and evoke a range of emotions. Find prints that are blunt and raw, depicting subject matter that conveys the real world. What is it about the prints that moves you? How do printing techniques reinforce the vision?

The power of black-and-white photography is due largely to the medium's range of expression. It can communicate just as effectively in scientific and political realms as in social and emotional ones. Thus, the viewer can feel empathy for the immigrant family as they first arrived on the docks in America (top) or wonder at the abstraction of surrealistic forms in the Bisti Badlands (bottom). Both images "work" in black and white, though they speak to very different realities. (Photo at top: National Park Service; photo below: Grace Schaub.)

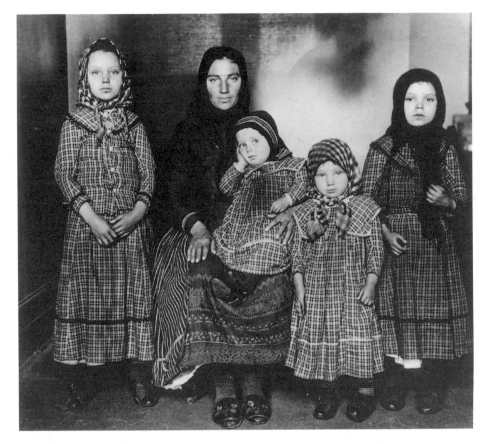

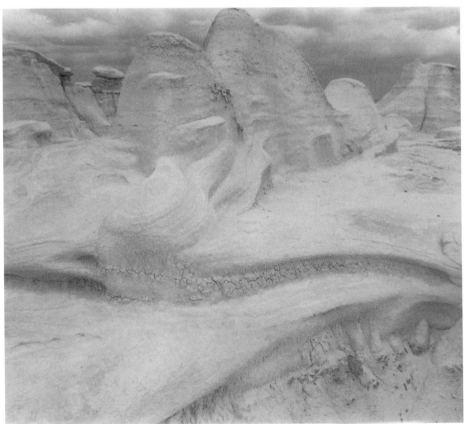

Next, study prints that portray a more ethereal world—those that use lighter tones and a quality of light to communicate a specific visual space. Also study photographs in which the tonal richness seems improbable, where reality seems to be exaggerated in an enhanced version of a time or place. In each case, consider how the subject matter is enhanced or diminished by the technique. How do somber tones add mystery or mellowness? How does the use of high contrast change your point of view? How does the use of light affect your sense of time and place?

As you grow to understand how printing affects the way in which a photographic subject is seen, you will gain an appreciation for the artistic control that a photographer exercises through creative choices. You will see how deliberate choices and an educated intuition shape the visual and emotional message that each image conveys.

Each print you study has something to teach, whether it is a photographic success or a failure. Of course, looking at many failed prints can be discouraging, but exposure to a wide variety of images will help you define your own path of visual expression in the future.

Studying the Classics

Reading about photographers and printmakers you admire can be very helpful. Unfortunately, too few of those who print well have made it a practice to write about their techniques, but there are some books and articles of value. Read about Eugene Smith's perception of the essentials of good print, or the ways in which Ansel Adams, Minor White, or Paul Strand worked. Their techniques are guided overall by what serves the image—a practice most photographers/printmakers profess to follow. Also note that their techniques enhance their ability to communicate.

Continue your study by closely examining the masters' prints in galleries and museums, where the lessons these masters teach are revealed most vividly. In effect, your study of this work is a form of apprenticeship and an opportunity to understand what came before. There is little sense in reinventing the wheel by emulating those you admire, or in limiting your techniques to those that may have served another time or a particular type of subject matter. On the other hand, gaining a foundation in the best of what the craft has and had to offer is a means of developing a visual literacy concerning the medium.

Some of the shared associations that form our appreciation of black and white come from images that have etched themselves on our cultural memory. Name some images, and among them you may envision Margaret Bourke-White's image of Gandhi at the spinning wheel; Dorothea Lange's Farm Security Administration photograph of the migrant mother and her children; Eddie Adams's shocking series of the assassination of a Viet Minh guerrilla; Harry Benson's playful shot of the Beatles in their hotel room; or Richard Avedon's portrait of Andy Warhol.

Photography has come to form a cultural and political framework in which we relate to our history and heritage. Among the classic photo series that should be studied is the work produced by the Farm Security Administration photographers in the 1930s. Although produced to stress the need for legislative programs, FSA photos have come down to us as an outstanding body of work that gives a sense of people and their times and also serves as a testament to the power of photography to observe and comment upon the human condition. (Photo: Dorothea Lange, Farm Security Administration, Library of Congress.)

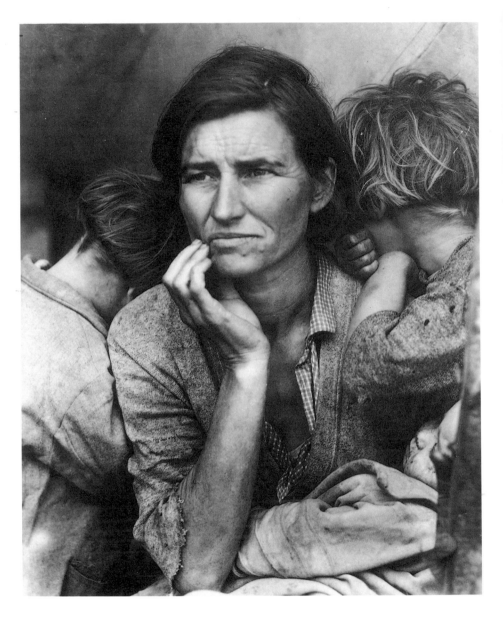

A Study in Seeing Prints

Continue to develop your visual literacy by seeking information from many sources—from books, exhibits, workshops, classes, and printers with whom you may work. Then begin to explore your own form of expression. Focus on the shared visual associations and techniques in the work you have seen. As you do so, you will begin to shape your own personal vision, and the techniques you employ will serve your art.

In summary, begin to see, have something to say about what you see, and then communicate it through effective techniques.

The photographic print is, in fact, a startling form of visual communication. There is a shock of recognition about the subject matter and the way it is realized. There is an understanding of how intent has joined vision and how the result transcends the

medium itself. This sudden recognition is experienced by many the first time they truly see a print by Ansel Adams, Minor White, or George Tice. For this writer, the seeing involved a print by Walter Chappell. While there can be many reasons for such realization of experience, it may have to do with the photographer's intimate understanding of what it means to see photographically and the powerful way that perception is translated into a print.

PRACTICAL MATTERS

While the artistic aspect of photography may be what motivates many people to become involved, consideration must also be given to certain practical matters. There is no question that the end use of the image plays a strong role in how it is handled. For example, a print made for the gallery wall should be printed in a different way than a print used to illustrate a newspaper article. While this difference may not be of immediate concern to you, keep in mind that there is no one set way to make a print, and that flexibility in this and other matters will yield better results in whatever venue your work may be viewed.

The "generational" factor of reproduction, which changes the look of a print when it is reproduced in another form (either as an illustration in a book, magazine, newspaper, and so forth), is the cause of much anxiety for photographers. But once understood, techniques can be applied that optimize results, espe-

cially if the printmaker takes the time to adjust to the needs of the reproduction venue. Fortunately, the flexibility of black and white allows for many such choices to be made and for very subjective approaches to virtually every image.

Subjectivity must be foregone, however, when it comes to the practical applications of the craft, such as the way chemicals are mixed, the way film is processed, the way exposures are made and read, and so forth. For example, ignoring time and temperature control in film developing will cause many problems when you attempt to make a print, and confusing the order of chemical baths in processing will ruin all your efforts.

That is why the discipline of the craft must be applied to the art of photography. There are stages of understanding that all photographers pass through, given time and practice. Fortunately, much of photography has been greatly simplified from

Visual instinct is learned and sensed. Taking a photograph is combining a sense of presence, or visual awareness, with an act of will, or acquisition. This awareness may come from a recognition of what speaks to you, though that speaking may be without words. This awareness also comes from developing visual literacy by studying photographs that touch you or perhaps shock you. Understanding how others express themselves with images is key to this growth process, as is finding your own images and places that resonate within you.

a technological standpoint, but there are challenges remaining.

Photography, then, is a blend of art and science, in which practice of the art necessitates understanding the science. In turn, the science, or technology is there to serve the art.

Steps in the Photographic Process

There are a number of practical steps that are taken in the creation of photographic prints. If properly completed, each step builds toward success. These steps are discussed in detail in later chapters of this book. The following overview serves as an introduction to the process.

The first step is making a film exposure in the camera that will faithfully render the brightness values in the original scene and will result in a negative that is easy to print. While automatic-exposure cameras have made this considerably less of a challenge, there are certain lighting conditions and subjects that can be challenging.

Reading the light in the scene—and making judgments about how that light best translates to film—is one of the most critical aspects of photography. While remedial steps can be made to correct minor exposure errors, a badly exposed negative is one of the major headaches in photography. The aim is to balance the sensitivity of the film with the light values, and to do so in a way that emulates a range of those light values on the film.

The second step in the creation of prints is developing the film, or making

the image visible. The developing process uses three chemical solutions—developer, stop, and fix. Each solution must be mixed properly, and the film must be developed in a specific order, for a specific time, at a specific temperature. There are numerous variations in developers and developing techniques, each of which has implications on how the image is rendered on film. You can simplify all this by using one film and one developer, although it can be interesting to experiment.

The final step in making prints is the printing itself, which involves creative decisions about how the light originally captured on film is to be rendered on paper. This, too, requires three essential chemical baths, though making a mistake here means only wasting a sheet of paper—not losing the original image. The print-making step is where most artistic choices can be made and where the actions of the first steps are finally put into a form that can be shared.

Challenges and Rewards

Black-and-white photography can be challenging—even intimidating—to some people. It demands more than the automatic photography we may have become used to, where the promise of push-button magic keeps us on the narrow path of others' interpretations, tied to the photofinishing industry. With the freedom of black and white come the opportunity and the responsibility to make creative choices.

Each step of making an image—exposure, development, and print-making—has many variations, any of

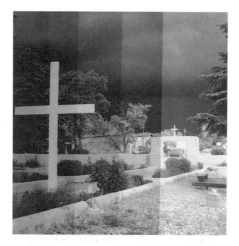
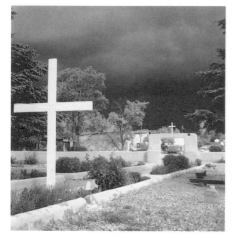
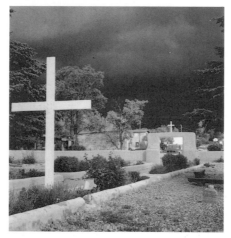

There are a number of practical steps that take you from identifying a potential picture to holding a print in your hand. The first steps are exposure and development of the negative, matters that include light readings and chemical processing of the film. Exposure and development create the foundation of the image—the negative (top row left)—which is intended to faithfully render the scene on film. The next steps take place in the darkroom, where prints are made. There, the first step is making a test-strip print (top row right), which pinpoints paper exposure and contrast grade selections. The test-strip print is followed by a work print (bottom row left), a serviceable rendition of the image. Finally, there is the refined print (bottom row right), which incorporates specific light controls and printing techniques to enhance the image. Decisions made at each stage of image creation can have a profound effect on the power and effectiveness of the final image.

which lead the photographer down a different path. Although the medium can be as expressive or as neutral as desired, the message of the image is partly contained in the critical choices made by the creator. The power of the craft is in making choices, and the reward is in being able to make choices that matter, that sway the viewer, and that effectively communicate feelings and thoughts.

Part of the challenge of black and white may also include freeing oneself from fixed modes of expression. Photography is, in fact, a relatively young art form, yet there have been waves of academics who have claimed that their printing techniques or subject matter is the only path.

Beginners and students often are taught that prints are to be made in a strict fashion, regardless of subject matter or end use. Unfortunately, such a lack of leeway in approach serves only to restrict the opportunity for self-expression.

Conversely, there are those who assign images to categories and claim that each type of subject matter has a set printing motif. This school of thought maintains that, for example, an image of nature should be printed one way and a cityscape another. While this may be a convenient approach, it generally leads to clichés.

Taking the time to think about what approach best serves your work and having the technical ability to

An effective and emotionally charged image speaks for itself, but choices made in exposure and printing will enhance or detract from a print's power. Light, whether dark and somber or bright and effervescent, is the medium in which photographers work, in addition to the tonal play and light rendition within the image. This photo is more than a portrait of a man reading his paper; it is also a son telling us about his father. The light and the print technique add a great deal to the story told. (Photo: David Wade.)

make it happen are the challenges. Knowing your options and knowing how to apply them to the image at hand are of equal importance.

Keep in mind that there is no one "right" approach to any image. As you grow and change, you may see that the choices you were so adamant about in the past will become less important, and that new ways to express yourself will be revealed. This is natural, reflecting your changing view of the world as you grow in age and experience.

As we discuss various techniques throughout this text, think about how you might apply them to your own images. When you photograph a landscape, for example, usually you are attempting to communicate a sense of place. The techniques you apply define both the objective place and your perception of that place. You can create an image that is pervaded by bright light, or one that is set in deep, dark tones. The essential image of the place has not changed; the change comes from the way the image of that place is interpreted by you, and thus is seen by the viewer of the print.

Continuing with the landscape example, the way in which the landscape is first recorded on film will also have a profound effect on the final image. A tree on a desert plain with a background of cloud-filled sky will look quite different when photographed on panchromatic film or on infrared film.

If we expose the film poorly, or develop it incorrectly, what we hoped would be a revelatory image will be harsh and artless. Then again, that

may be the effect we are aiming for (justifying poor technique is an art in itself). It is not the purpose of this discussion, however, to encourage turning things on their heads in order to find a personal approach. Rather, good exposure and proper developing are always the best course, as they allow the most creative leeway.

Finally, how the print is made also contributes to the sense of place. Skies can be deepened or lightened. The tree and ground can be printed in high contrast or in soft gray tones. Each choice is critical to your interpretation, that is, the sense of place you communicate.

In summary, there should be few restrictions on how the print is made, or on how the photographer uses technique to enhance expression. As long as the image works and the photographer carries it off successfully, then little argument can be made about how the print fails to meet the standards imposed by others. Just be aware that deviations from the path usually are given more scrutiny than approaches that follow conventional rules.

Interpretations

The point of view of the photographer is conveyed by the way in which a scene is visually framed. That frame may be modified by the use of various lenses, by the physical position of the photographer, and even by the type of film in the camera. Point of view also is defined as the social or political stance of the photographer, and how that position is reflected in the scene. Any of these definitions of point of

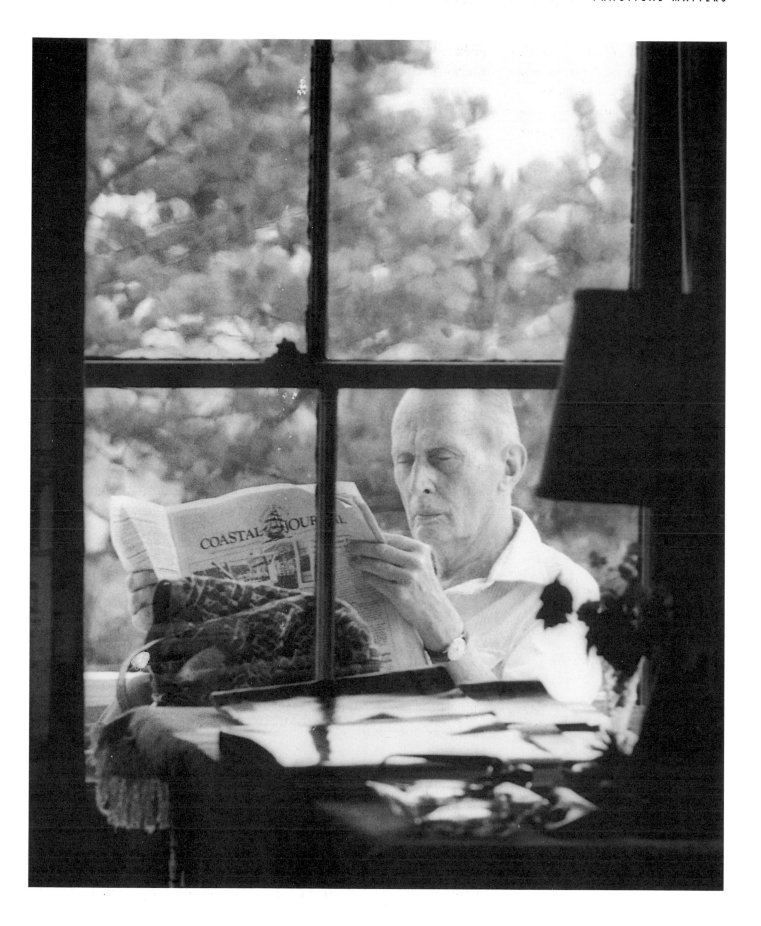

view can be emphasized through exposure and printing techniques.

A news photographer once told this author a story about his assignment to photograph H. R. Haldemann during the Watergate hearings in the 1970s. A close advisor to President Nixon, Haldemann shared his boss's negative feelings about the media, and the feelings on the part of the news organizations were mutual. The photographer shot about twenty rolls of Haldemann during the hearings, capturing his various facial expressions from different angles.

After the film was processed, the editing began. The photo editors, realizing their boss's attitude toward Haldemann, chose the most scowling expression and the frame that was harshest in lighting and tone. In print, the picture appeared even harsher. The choice of the subject's expression was one way the editors conveyed their message; the communication of that message was enhanced by the way the image finally was printed.

Propaganda sometimes is comical in the exaggerated way in which it is rendered. The abuse of images (now more perfidious with the possibilities afforded by computer imaging) to convey a sense of security about "our" side and fear or mistrust about "their" side is easily noticed and is the subject of many psychological studies. But the lessons learned from the manipulation of images for political purposes also apply to virtually every type of photography.

For example, in portraiture the use of high contrast or soft focus tells us as much about the subject's char-

acter as it does about the photographer's interpretation of that person; in fact, we often confuse the two and allow the photograph to influence our perceptions of the subject. This is carried to its height in Hollywood's classic stills of heroes and villains.

The ability to influence the viewer through critical exposure and printing choices is one of the powers granted to photographers. People and places are made accessible, friendly, or inviting, or are portrayed as closed, hostile, or alien—all conveyed by the way in which the image is presented. This is not to say that the viewer of the image comes to the table without preconceptions. Indeed, cultural baggage is part of the visual experience of virtually every picture. The photographer cannot always know—or perhaps should not even consider—those preconceptions. Nonetheless, they are part of the photographer/viewer interplay and should be understood and appreciated by every photographer and printer.

THE BASICS OF IMAGE FORMATION

The black-and-white image is formed by the action of light (exposure) upon light-sensitive silver salts imbedded in an emulsion (film); these silver salts reduce to metallic silver to form what is called a latent image. This image is amplified by treatment in chemical baths (development) to create a pattern of silver densities that we see as a negative image. This negative is then made positive when it is project-

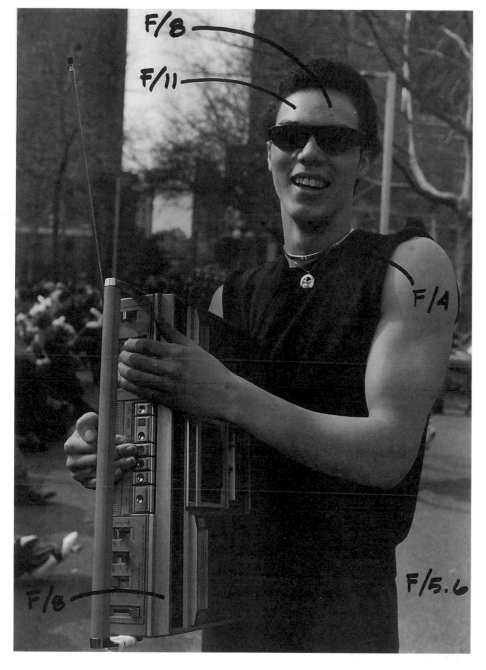

The content of an image can be success-fully enhanced or lost in obscurity depending on how light is handled. Here, every detail of the young man and his radio was revealed by the correct place-ment of light values in exposure, which was followed by close attention to detail in developing and printing. Thus, creat-ing a successful image involves paying careful attention to making an exposure that records the available range of tones, understanding how contrast and bright-ness values work together, and making exposure decisions that faithfully render a scene. The callouts here show the range of brightness values, indicated as f-stops, that are within this scene.

ed onto photographic printing paper or other photographic material.

When we use the camera (includ-ing a light meter for reading the light and the aperture and shutter speed for controlling the light), we allow a pre-scribed amount of light to reach the film, which itself has a certain sensi-tivity to light. If all is in balance, the densities, or deposits of silver in the film, will be proportional to the brightness values in the scene; also, the ratio of various densities (or con-trast) will match that found in the original scene. In the negative, the brighter values in the scene read as greater density on the film (appear darker in the negative) than do the darker values in the scene (which appear lighter in the negative). Thus,

Grain is the visual manifestation of a film's light-sensitive silver-halide material. Faster (more light-sensitive) films exhibit larger grain clumps than do slower-speed films, because the larger the area of the grains, the greater the light-gathering ability. Here, an ISO 400 film has been "pushed" to EI 800 to handle the low interior light and to obtain a deeper depth of field. Although doing this does yield a gain in light sensitivity, it is accompanied by more grain, causing a salt-and-pepper pattern in the image. To a certain degree, grain is not objectionable and can become a graphic element that helps shape the look of a photographic print.

brighter light effects a greater change which, when the negative becomes visible through development, we see as more density; dimmer light causes less change, thus less density.

The relative relationship of light to dark (contrast) in the negative should be the same, or at least similar to that found in the scene, though of course the values will be reversed. If contrast is out of balance, caused by too much exposure (overexposure) or too little exposure (underexposure) to light, then the relationship of light to dark and the recording of all the values in the scene will be inaccurate. (And, as we will see, proper development also affects success.) The degree of imbalance will affect your ability to make a good print. In fact, severe imbalance may make it impossible to ever successfully render the scene in a print. Under such conditions, even a passable print is difficult to obtain.

The amount of light, or exposure, required to create an image on film depends upon the size of the silver-halide grains in the unexposed film and how efficient they are in capturing light. Generally, the larger the area of the grain, the more light-sensitive, or "faster," the film. Grain becomes manifest when we develop and make prints from that image.

This relative sensitivity to light is expressed as an ISO—International Standards Organization—number; the higher the number the more light-sensitive the film. Figure 1.1 shows an equivalent exposures chart with the associated ISO numbers. The relative sensitivity is expressed in the progression of film speeds. For example, an ISO 100 film is twice as sensitive to light (it takes half as much light to get an equivalent exposure) as an ISO 50 film. An ISO 200 film is half as sensitive to light as an ISO 400 film. As grain size determines film speed, the faster (more light-sensitive) films usually exhibit more grain than their slower-speed counterparts.

Though this discussion of grain may seem of abstract interest, grain is a major concern when making black-and-white prints. Some photographers will go to great lengths to eliminate grain from their work, while others see grain, in reasonable amounts, as the signature of the photographic medium.

As mentioned, the image formed on film becomes visible only when the film is developed. Development comprises three main chemical baths, followed by washing and drying. The first step, called the developer, amplifies the latent image to a visible image; silver deposits in a range of densities result. The second step, appropriately called the stop bath, stops that reaction; the third step of development, called the fix, removes the unexposed silver halides from the film so that no further exposure will occur when the film is brought into the light.

The same image formation steps are followed when prints are made. The negative is projected onto light-sensitive photographic paper, and the paper is then processed in three basic steps to make the image visible and fixed. Most negatives are created with one burst of light. Often, however, a custom, or handmade, print is subjected to one main exposure, followed by a series of refining exposures to add selective amounts of light to parts of the scene. This additional exposure is called "burning in"; holding back exposure from select areas of the print is called "dodging."

These terms and their application will be discussed further in the printing section of this book. They are mentioned here to illustrate that there is a good deal of control that can be employed when prints are made.

Figure 1.1

EQUIVALENT EXPOSURES

The numbers shown are ISO, aperture, and shutter speed combinations that equal the same overall exposure value. ISO numbers express a film's relative sensitivity to light. Note how the greater light sensitivity of the film affects the exposure possibilities. For example, correct exposure for a given scene on ISO 400 film would be f/16 at 1/30 second; for the same scene an equivalent exposure with ISO 100 film would be f/16 at 1/8 second. The two-stop difference (1/30 to 1/8 second) equals the two-stop difference in film speed (ISO 400 to 100).

Aperture **Shutter Speed**

Aperture	ISO 100	ISO 200	ISO 400
f/4	1/125	1/250	1/500
f/8	1/30	1/60	1/125
f/16	1/8	1/15	1/30

Black-and-white images are composed of a set of tonal values within the gray scale, which ranges from open white to deep black, with all the shades of gray in between. Although the differentiation between shades of gray can be extensive, photographers have simplified those differences into a scale of ten zones, or steps, of ever-increasing lightness from black to white. The steps between each zone are roughly equivalent to the change in density in film equal to one stop of exposure, assuming that consistent developing procedures have been followed. This system allows photographers to make fairly good predictions about tonal value records in relation to exposure and development and helps them visualize how highlights and shadows will be rendered on film. In the Zone System, middle gray is called Zone 5; white with texture is Zone 7; deep gray with texture and information is Zone 3. Here, a number of zone values are shown on a print.

Some Terms Defined

In black and white the tonal scale goes from bright, textureless white to pitch black. Between these extremes is a range of gray tones. Many people break this gray scale (including pure black and white) into ten steps called zones. If there were truly only ten steps in our palette, this would be a very inexpressive medium. In fact, there are many more steps and nuances of tones than ten, though compartmentalizing certain values does help to simplify discussion.

The word *tone* often is used in discussions about black and white. It is used to describe the chemical coloration of silver images; the overall impression of a print; the color bias of a monochromatic image (such as "warm" or "cold" tone); and/or the specific steps on the scale of values

described above. Perhaps the word is used so often because black and white is akin to music; indeed, you will notice that many terms (*tone, key, scale*) are common to both.

Contrast refers to the relationship of light and dark values in scenes, negatives, or prints. When talking about the scene we are photographing, contrast is the relationship between highlights (brighter areas) and shadows (darker areas). Bright days with strong shadows equal high-contrast scenes; overcast days with weak shadows are low in contrast. In practice, measuring the brightest part of the scene in which we wish to retain detail or texture in the negative (the principal highlight) and comparing it to the measurement from the area with significant shadow detail (the darkest area in which we want to record informa-

Contrast is the difference between the brightest and darkest light values in a scene. Film has the ability to record information within a fairly broad contrast range; however, there are lighting conditions that are so contrasty that decisions need to be made about what visual information should be sacrificed or what action needs to be taken to record as much information as possible. In this scene, the shadow details are a key element, though the original light on the boat was extremely bright. Exposure was determined by reading the shadow area and subtracting two stops, which retained shadow detail on the film and overexposed the highlights. Film developing was altered to control the highlights, and extra exposure was given to the boat during printing—a technique known as burning in. Contrast control requires an appreciation of the range of contrast that film can successfully record and the application of exposure, developing, and printing techniques in order to retain as wide a range of brightness values as possible.

tion) gives us the working contrast of the scene.

After exposure, the contrast recorded on the film again is affected by the time and temperature of development, as well as by the nature of the developer itself. Extended developing times, higher temperatures, and/or more active developer will have the effect of increasing film contrast.

Contrast of the printed image is affected by the contrast of the negative, of course, but also by the contrast of the paper on which the negative is printed. Thus, contrast can be manipulated by several means—through exposure, development, and

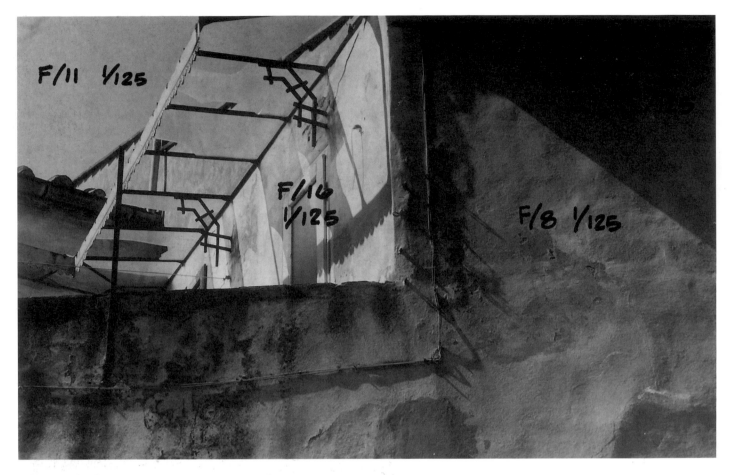

Contrast range can be determined by making exposure readings of various brightness values within a scene. When making such readings, keep the shutter speed constant and use the f-stop as your variable. Read the brightest part of the scene in which you need to record detail (the principal highlight) and then find the contrast difference by reading the darker portions of the scene in which you want detail (the significant shadow). The range can be expressed in stops; for example, a scene with a range of f/16 to f/8 has a two-stop range; a scene with a range of f/22 to f/2 has a seven-stop range. The former presents no exposure difficulties, while the latter is very high in contrast and presents difficulties in exposure. Note the contrast range as expressed in f-stops in this scene.

choice of the contrast grade of the paper used in printing. As we will see, contrast manipulation is one of the main expressive tools in black-and-white photography.

Reading a Negative

The aim of exposure and development is to produce a negative that will yield a representation of the tonal values in the original scene with a fair amount of ease when printed. As you gain experience in shooting, developing, and printing, one key talent to nurture is that of being able to *read* a negative, that is, to see in reverse and to appreciate the tonal richness as it stands and as it will print. Reading the negative properly also will be invaluable in

controlling and enhancing contrast when prints are made. As you study more negatives, you will see how tonal richness offers rewards, allowing for the greatest printing freedom.

What you may also notice is that there is some inevitable compression of the tonal scale when going from scene to negative, and from negative to print. While this may serve as the source of some frustration, it will lead you to do whatever you can to maximize the materials and to gain the most from your technique. Poor technique will only emphasize compression of the tonal scale.

Further, you will discover ways to enhance images and to enjoy the flexibility of the medium. In many cases, the print may reveal what the eye does

not at first see, as the process of printing can depict what you may have seen on another level in your mind's eye.

These basics will be expanded upon as we discuss each aspect of the process throughout the text. While the terms may seem more an abstraction than a reality, study and practice will reveal the interrelationships in the photographic process. The definitions are actually simplifications of a fairly miraculous process: the ability to fix light—and a moment—on paper and film.

THE SEARCH FOR PHOTOGRAPHIC MEANING

Before we begin to discuss the historical background of the craft in the next chapter, we should consider just what it is that motivates us to make pictures and to recreate images in a certain way on film and paper.

There is no obvious answer to this query. Indeed, photographers often are baffled by their own motivation, or claim that analyzing the process too much stifles their creative instincts. Critics have written that we photograph in order to acquire and control, and that these innately human endeavors have found a ready vehicle in picture taking.

Others see the photographic process as a means of self-definition—as an imaged autobiography. They seek the inner self in every photograph. Still others take it deeper and see photographs as representing internalized forms that are photographed when recognized, no matter how abstract or laden with cultur-

al baggage they may be. Even followers of the philosophers Plato and Marx have shared their analyses of photographers and photography.

Just as a group of paintings moved the nineteenth-century Russian composer Rimski Korsakov to create a suite of program music entitled "Pictures at an Exhibition," photographs can inspire a wide variety of responses, both verbal and nonverbal.

Generally, the degree to which we can analyze a photograph is proportional to the amount of time we wish

Photographs are open to many interpretations. The personal, social, cultural, and even political stance of the viewer will determine some of these interpretations. The complexity of an image can feed the imagination and call forth associations on many different levels. While not every photograph was originally created to evoke deep meaningfulness or to serve as an autobiographical statement, there is the potential for analysis and discussion in even the simplest visual expression. That is part of the fascination of photography.

to spend doing it. There are so many layers to an image—spiritual, psychological, emotional, and so forth—as well as the cultural layers self-evident in the subject matter. Taken to extremes, even the simplest snapshot, accidentally made when loading film, could be the subject of in-depth analysis.

This does not imply, however, that the photographer should ignore the search for meaning in personal work; indeed, the complexity of images should feed the imagination. But how can one start the imaginative process?

Some photographers begin by developing themes—whether they link subject matter, tonality, or the quality of light. Next, they consider why the theme was chosen. Others, however, find choosing a theme to be an artificial way to conduct a photographic self-exploration. Often, as a photographer works over time, themes emerge in and of themselves.

This emergence of themes becomes apparent when reviewing work from a given era, or when looking at work created in a certain emotional space. Though this may also be rationalization, the insight gained is a more natural, intuitive one. One profound aspect of photography is the transformation process that takes place between the time the image is captured on film and when it is printed. This process, which often adds layers of meaning and, hopefully, understanding, can occur in a day or, with rediscovered images, over many years.

After it is printed, an image either continues to hold power or is discarded on the editing floor. Those images that endure and remain vital to the photographer through the various stages of his or her life are those that truly define the photographer's vision.

This discussion is not meant to place a burden of meaning upon each image, or to suggest that each picture printed must be a personal, temporal, and universal metaphor. There are just too many images made and printed in a lifetime for that to make sense. Yet photography does offer a means to make a statement about self in the present that can be reflected upon throughout life. And if that statement is shared, it can preserve an individual consciousness.

In summary, an image can fix a moment in time in a way that no words or sound can recreate. Such captured moments are at once documentary and spiritual. Pictures easily communicate information about the external world, yet we have the option to look at them as windows into an internal world as well. Because pictures are so powerful and compelling, the study of the art and craft of photography becomes a truly artistic endeavor. At once creative, spontaneous, and interpretive, photography allows us to glimpse the surface and the depths in one intuitive, split-second glance.

HISTORICAL REFERENCES:
THE INTERTWINING OF ART
AND CRAFT

HISTORICAL REFERENCES:
THE INTERTWINING OF ART AND CRAFT

Today we expect that films will be fast and consistent. We take for granted readily available printing papers that deliver a full range of tones with short exposure times; prints that can be enlarged and processed in a matter of minutes; and portable cameras that will yield precise exposures and automatically wind and rewind film with push-button ease. Indeed, time and technology have wrought a whirlwind of change. Despite this, the principles of photography are not radically different from those used in the nineteenth century. The difference today lies in the ways in which images are captured and printed.

Early cameras were cumbersome devices that, due to printing constraints, had to produce images the same size as the final print. In addition, early films had to be hand-coated immediately before exposure and required exposure times that, by today's standards, were exceedingly slow. Prints were made using the sun as the light source; a cloudy day meant no printing, or printing times that could stretch to half a day.

Fig. 9.

Fig. 10.

Witnesses.
Chas. R. Burr.
Thomas Durant.

Inventor.
George Eastman.
by Church & Church,
his Attorneys.

Early snapshot cameras were simple devices that afforded little creative control. However, their introduction in the late 1880s engendered a revolution in the making and collecting of images, one that continues today with billions of photos being made every year.

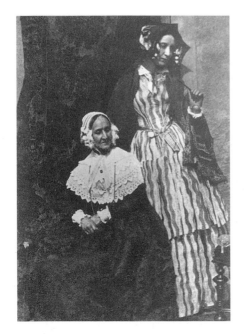

In the first forty years of photography, cameras and the processes of making images were cumbersome affairs, making the conditions under which the photographer worked difficult at best. Despite these hindrances, images were made that still hold our interest and respect today. Early portraits by the team of Hill and Adamson, made in the 1840s, are stunning in their depiction of their subjects. Some argue that their work ranks among the best photographic portraits ever made. While Hill and Adamson were restrained by slow emulsions, large cameras, and the difficulties of making an image on paper, they transcended these problems to record their contemporaries with a presence and power that is remarkable. (Photo: New York Public Library.)

A study of the art and craft of photography can take a variety of paths. It is not the intent of this text to serve as an historical survey, as there are many books devoted solely to that purpose and to those photographers who were technical and artistic pioneers. Instead, this chapter presents an overview of some of the developments that shaped modern photography and places them within the context of today's practices. From this foundation the reader is encouraged to explore further.

TECHNOLOGY AND VISION

When lovers of great literature gather, they rarely debate the make of typewriter used by Hemingway or the quality or characteristics of the paper on which he typed his first draft of *A Farewell to Arms*. Photographers, however, tend to spend an inordinate amount of time discussing equipment and technique. Naturally, lively talks about inspiration and vision take place as well, but critics and outsiders seem to disdain the important matters of craft. Yet, those who practice photography know instinctively that there can be no wall between the art and the craft of photography. Indeed, photography shares with other art forms the fact that the discipline of the craft equals freedom of expression.

Even the briefest study of photography leads to the conclusion that the greater ability to express, and the expanded modes of expression, are intimately tied to the evolution of the ways and means of taking and making pictures. The mechanics of camera, film, and printing are often as much a part of the image as the idea communicated in the image itself. Though new ways of seeing are at the core of the evolution of photographic art, the defining principles of that vision are largely determined by the equipment and chemicals used to manifest that vision.

Some argue that portraits made in the first thirty years of photography surpass in beauty, charm, and revelation of the human spirit those made today. Perhaps those images were even more startling to their contemporary viewers than most photographs are to us today, if only because the medium was nowhere near as prevalent as it is now. Yet the revelation of character in today's fine portraiture could only be achieved with today's equipment used by today's photographers. That is why with each progression in technology there is so much more visual expression to explore.

Photography emerged during the industrial revolution—a period typified by alienation and dehumanization. Yet it was also the darling of the age of discovery and grew alongside other profound changes in the visual arts. Photography addresses most directly the very human need to communicate through images and plays upon the human ability to empathize with abstract forms. Thus, the mechanical serves the artistic, which in turn creates communication on virtually every level of visual perception.

The link between the art and the craft dates back to the time of the

pioneers of modern photography. Many of these early explorers were artists seeking new and more efficient ways to create images from nature. Many were men and women grounded in the scientific method of discovery, yet who associated with circles concerned as much with aesthetics as with experimentation. At that time, the lines between science, art, and craft were not so clearly drawn. Curiosity drove the inventor, rather than the determination to create prepackaged solutions to meaningless problems.

PHOTOGRAPHY'S BEGINNINGS

The elements that came together to create photography developed for many years prior to its formalization in the 1830s. The camera evolved from the *camera obscura* and *camera lucida*—devices used by artists to capture images from nature as an aid to painting and drawing. DaVinci is said to have used such devices, as did William Henry Fox Talbot, a scientist and weekend painter whose frustration with his lack of drawing skill is said to have driven him to explore ways to fix the image captured in his drawing box.

In the eighteenth century, various experimenters studied the effect of light upon silver salts. They found that the salts were affected by the action of ligh, and that even a vague image could be formed in such a fashion. The images, however, were ephemeral, as they darkened and disappeared when exposed to further light. There

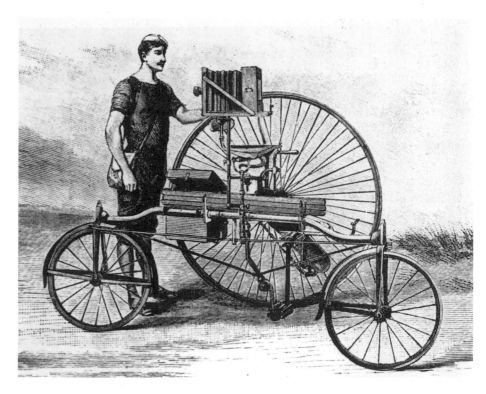

was no way found to "fix" the image after its initial exposure.

The problem was that early photographers had no way to remove the unexposed silver salts after the initial image was formed. Strangely enough, this hindrance to photography's invention was solved a full twenty years prior to its now-accepted inception date of 1839. In 1819, English scientist John Herschel found that hyposulfite of soda performed the task admirably. (The shorthand for this fixing bath—hypo—still is used today, despite the fact that modern fixers are generally composed of sodium or ammonium thiosulfate.)

The main currents of photography's development appeared in England and France during the early nineteenth century. Louis Daguerre, a Parisian promoter and showman who was known for his immense painted fantasy worlds, called *dioramas*,

Inventiveness has always been a part of the vitality of photography. While we expect portability and ease of use with today's cameras and film, early photographers were faced with the fact that the final size of the image had to be the size of the plate exposed in the camera, and that their "film," or plates, had to be sensitized right before exposure and developed immediately afterwards. This odd contraption was one solution to making a large camera easier to move about.

began working with a more reclusive gentleman with the generally mispronounced name of Nicéphore Niépce. In England, Talbot also began his experiments in earnest.

Daguerre's work with Niépce (and with Niépce's son, who continued the work after his father died), resulted in the Daguerreotype, a direct-from-the-camera positive exposed onto a silver plate. The image produced was startling in its detail and in the virtual likeness of its subject. Talbot's results in their final form were broader in their definition, partly due to the fact that the positive print was made by contact printing a paper negative that had been exposed in the camera.

It is one of the odd facts of history that the first expressions of photography would echo in an artistic debate that sounds throughout much of the history of the medium—that between the "romantic" or broader

forms and the more delineated or precise approaches to photographic expression. This debate reached its height at the turn of the twentieth century, and still has remnants today. The approaches, however, did not necessarily spring from an artist's fervent commitment to an art style. Rather, they were defined, quite simply, by what the different mediums were capable of delivering.

Though the Daguerreotype certainly delivered the most precise impression of reality, Talbot's approach to photography—that of a negative exposed in camera that was used to create the positive image— won out not because it produced a better image, but because it could be reproduced. Daguerreotypes were one of a kind; such preciousness in such a promising commercial venture could hardly be expected to survive in the industrial age. Fame was fleeting, however, for even Talbot's system (though not his approach) was virtually abandoned a scant ten years after its announcement in 1839.

Despite the fact that both these forms of photography were eclipsed by new technology, the fever for picture taking that resulted fired inventive and entrepreneurial spirits throughout the world. Daguerreotype portrait studios opened throughout Europe and America. Mathew Brady, who later became famous for his portraits of Lincoln and images from the Civil War, was one of the first adopters of this process. In one of the early instances of pictures selling politicians, Lincoln often said that

Although the Daguerreotype is mainly associated with portraiture, this scene was recorded using that direct-positive process. As seen from the borders around the image, Daguerreotypes were often mounted in elaborate cases that served as frame, holder, and backing. This method of presentation was necessary to view the positive, silver-plate-backed image properly. (Photo: Courtesy Eastman Kodak.)

Brady's portraits of him won him the election.

Talbot's process was less widely disseminated, owing to the fact that Talbot, unlike Daguerre (who released his patent in return for a pension from the French government), guarded the rights to his process zealously. Because of the obvious advantages of the Daguerreotype for portraiture, Talbot's process, called the Calotype, was used mostly for landscape and still-life photography. Talbot's "Pencil of Nature" and other such publications began appearing. As there was no way yet to reproduce photographs on page, each image in these books was an original print.

Though not particularly adept at rendering portraits, at least in relation to the Daguerreotype, the Calotypes most admired are, ironically, portraits. The team of David Hill and Robert Adamson made a series of Calotype portraits as study prints for a large mural painting of church members. In another twist of history, the painting is long forgotten (and wasn't very good), but the study prints stand in most critics' eyes as among the most eloquent photographic images of humanity ever made.

IMPROVED MATERIALS

Early photographers were bedeviled by the slowness of their sensitized materials. Though exposure times were eventually shortened to workable lengths, early studios used neck braces and confining chairs to keep

their subjects still while the exposure was being made. Our perception of the people who lived in those times may be formed by those necessarily stiff bodies and staring faces; this false impression of a vibrant age is caused by the medium's low sensitivity to light.

The situation improved with the invention of the wet plate process in

Portraiture accounts for most nineteenth-century images. Studios and circuit-riding photographers offered Daguerreotypes, Calotypes, carte de visites, and other image-making systems to an eager public. The most affordable of these were tintypes, images mounted on an inexpensive metal plate.

1851 by a sculptor named Frederick Scott Archer; this process quickly rendered the paper negative obsolete. The film emulsion was flowed onto a glass plate, a medium that eliminated the textural interference and light-dispersing character of the paper negative. Though Daguerreotypes still were used for portraiture, they were slowly but surely replaced by the glass plate negative.

The gain was not without its problems, however. The plate was dubbed "wet" because it had to be coated with a light-sensitive emulsion right before exposure, then developed right after exposure. This tied the darkroom to the camera, which was not a problem in established studios but was cumbersome in the field. Photographers had to travel with their own coating and developing systems, which meant that pop-up tents, covered wagons, and jars of sensitizer went with them.

Printing papers went through similar improvements. Commercially available albumen paper, which literally used egg whites as the medium in which light-sensitive salts were suspended, became so widely used that it is said that the chickens of Europe and America were put under great strain.

These breakthroughs produced a wave of photographers working in scientific, exploratory, portraiture, and even fine art fields. Portraitists such as Nadar and Salomon became sensations with their images of the luminaries of their time. Nadar, a lively character who also was an avid balloonist, portrayed the writers and artists of Paris in straightforward fashion, allowing their strength of character and body language to distinguish them. Salomon drew upon the painterly modes of the eighteenth century and made studio portraits with elaborate drapings and props of the upper class. These approaches to portraiture—one frontal and spare, the other costumed and overproduced—continue today.

As photographers drew upon painters for their style, painters used photography as studies for their work. Arguments have been made that nineteenth-century artists drew more inspiration from photography than the artistic community (which often shunned photography) would care to admit. It is well documented that Degas, Goya, and many of their contemporaries used photography as a starting point for their work. The link between photography and the Impressionists is fairly obvious. Throughout the twentieth century, photography and painting became closely intertwined.

Photographers who took the wet plate into the field encountered the problem of the oversensitivity of the orthochromatic emulsion to blue, but overcame it by making two exposures—one for the sky and one for the ground. They then combined the two negatives when they made a print. This combination printing was picked up by fanciful artists such as Henry Peach Robinson, who collaged the pieces together with scissors and dye. His highly produced pictures depicted maudlin scenes from Romantic novels or bucolic idylls from imaginary countrysides. These

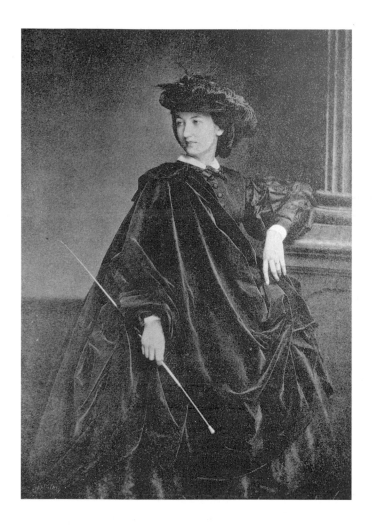

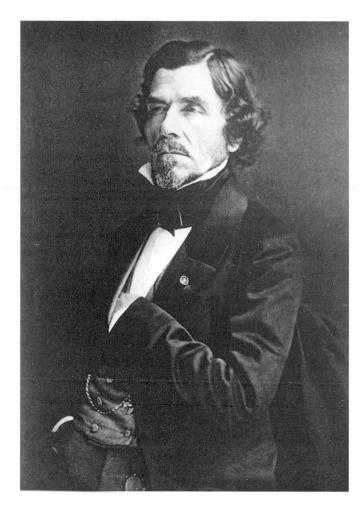

nineteenth-century, studio-produced images raised a cry of foul similar to the objections made today about computer-produced imagery. How could one ever trust that ultimate recorder of reality—photography—if it were manipulated with such disregard for the truth?

The newfound portability of photography fostered a group of adventurer-photographers who used the camera as their visual diary. The result was a catalog of people and places never before seen. Travel was difficult and harsh, yet the camera could bring back images to those without the means to make such trips. Even though the recording

medium had to be the same size as the final print (all prints were contact prints; the light source for printing was sunlight), this did not deter photographers and their crews from hauling their gear down the Nile, throughout the American West, up in balloons, down into mines, and into the streets of every major city in the world. This linkage between travel and photography and the acquisition of images from throughout the world began in earnest as soon as the apparatus—no matter how cumbersome—could be taken on the road.

Perhaps the most famous of American adventurer-photographers was Timothy O'Sullivan, a member

Photographers often drew upon painterly conventions for their stylistic approach. Yet, there was also a group of photographers who identified what was "photographic" and unique about the medium and broke new visual ground. These two nineteenth-century photographs illustrate trends that continue even today. The portrait by Salomon (above left) is grounded in a traditional or academic portrait painting style and shows a subject posed amidst the trappings of the upper class. Nadar's more confrontational portrait (above right) is eminently more "photographic" and boldly evokes the presence of the subject in a much more modern way. (Photos: New York Public Library.)

of a surveying team mapping out the American West. His photographs are as much a testament to the unsullied beauty and power of the frontier as they are to the tenacity of the photographer and his crew. As you walk the well-marked trails of the Grand Canyon, or fly overhead photographing with your fully automatic 35, take a moment to consider the challenges faced by O'Sullivan and others like him. They worked with cameras as big as 20 x 24 inches and larger and drove wagons piled with darkroom gear (and glass plate negatives) over some of the most rugged terrain known.

Photojournalists soon made their appearance as well, though their work often served as the basis of woodcuts and etchings that appeared in the papers. Photo reproduction in newspapers and magazines had to wait until the latter part of the nineteenth century for its debut. Roger Fenton's images from the Crimean War were the first from a battle zone, though his static images speak less to his taste for action than to the state of the photographic craft at that time.

Mathew Brady's pictures of the American Civil War were more confrontational, and some brought the reality of war, with its participants and victims, into full view. By the time of that conflict Americans had eagerly embraced photography, and the Civil War became the subject of the day. Battle caravans shared roads with hosts of photographers' wagons, and the photographer stood by as artillery exploded and cities fell. The link between photography and conflict, as reporter and/or propagandist, was forged by the mid-1860s. (The war photographers of the twentieth century were more apt to be in the trenches; though brave, they were not necessarily any more brave than their forebears—their equipment and film simply allowed them such access.)

The birth of true modern photography occurred during the period of 1870 to 1890 with the wet plate first being replaced by the dry plate (which could be prepared beforehand, thus freeing the photographer from being tied to the darkroom). This improvement soon was followed by the availability of film on a flexible support, rather than on glass. The speed with which these changes occurred, and with which one technology eclipsed and made another obsolete, is akin to what is happening in today's electronic imaging race.

Each technological improvement had a part in making the process of photography easier and more accessible to a greater number of people. Films and papers became faster (and, thus, more light sensitive), allowing photographers to experiment. Camera design followed suit, with hand-held cameras soon replacing the cumbersome devices with which photographers had previously labored.

Unfortunately, the technological boom led to the abandonment of numerous fascinating processes. Some had true merit, while others were odd hybrid techniques. What we now call "alternative processes" are those systems that were passed over in the rush to industrialize and

rationalize photography. Some were admittedly dangerous or impractical; others still can be explored with some comfort today, given a willingness to research old formulary books and buy component, rather than pre-mixed, chemicals. A short summary of some of these processes follows for those who might want to investigate alternative processing.

Curiosities abounded. The anthography process, for example, was a product of the mind of John Herschel (the man who discovered hypo, a much more useful revelation, and who gave us the name "photography," for which we are thankful). This process utilized the petals of flowers (the yellow tint of the japonica flower was recommended) ground to a pulp, squeezed through linen, and treated with a tincture of alcohol. This alchemical process supposedly produced a light-sensitive emulsion, but the exposure for a faint image required three to four weeks, and the resultant image was anything but permanent.

The fluorotype process used the salts of fluoric acid as a sensitizer, required a half-hour exposure and necessitated processing that included bathing the plate in hydrochloric acid. The erbeneum process of 1865 yielded prints that looked as if they were bound to ivory, but required fixing in cyanide and gold toning. The antimony process (1876) involved passing antimonitted hydrogen gas through a glass tube containing sulfur, which yielded orange antimony sulphide. Though it produced a very stable metal-sulphide print that

required no fixing, the fumes produced were highly toxic.

Herschel made another important contribution with his discovery that platinum salts were light-sensitive. Like his discovery of hypo, however, which took about twenty years to find a practical and widespread use, the broad application of the platinum process didn't take place until the 1880s, when an Englishman named Willis patented it.

Platinum is one of the most stable metals, and platinum prints have a subtle beauty that has made them the darling of the fine art collection market today. Platinum-coated papers were commercially available for a number of years, but those wishing to make them today must go through a careful and painstaking handcoating process. Recently, a number of small labs have begun offering a platinum-printing service both for individual prints and portfolio editions. Though quite expensive, some photographers consider this the ultimate medium on which to make prints.

Herschel also is credited with the discovery of the "everyman's" alternative process—the cyanotype—in 1842. Commercialized in the 1880s as the blueprint (for the blue color of the image), it utilizes ferric (iron) salts as the light-sensitive medium and is quite easy and inexpensive to create. Once the paper is handcoated and dried, it is contact printed with the film, exposed in sunlight or artificial light, and "developed" in water. Though cyanotype prints will fade in direct sunlight, they miraculously regain their composure when stored

The carte de visite was all the rage in the middle-to-late nineteenth century. These visiting cards were mass-produced by portrait studios and traveling photographers. The beauty of some of these old portraits is startling, and the portraits themselves have become some of the most vital visual records of nineteenth-century people and their social mores. Today, flea markets and antique stores are good sources for these images.

for a few days in a place that is cool, damp, and dark.

There's no question that many of the experimenters in photographic processes risked health and fortune working under less than optimum conditions. The old formulary books reveal many of these antiquities and oddities and make for interesting reading.

While simulating these old processes can be fascinating (Talbot's salted paper process, for example, is quite easy to recreate), the lesson learned is that modern film, paper, and chemistry are a blessing. Nonetheless, we should recognize that much of the insight concerning materials used today is, in fact, an accumulation of the energy of artists, chemists, and dabblers, rather than the product of corporate think tanks and research labs. Indeed, that spirit of independence and experimentation truly is a legacy of this craft.

BIG BUSINESS

The current state of the art, however, is the result of the influence of big business. For the better part of the eighteenth century, photography had been the playground of scientists, artists, highly dedicated (and usually well-to-do) amateurs, funded documentarians, and the new breed of professionals, who usually were portraitists.

As photography became easier and more convenient, the public appetite for participation in this most magical craft also grew. This led to the mass production of cameras,

chemicals and printing papers, film, and accessories for the weekend artist and family chronicler. In turn this drove the development of faster films, a wide variety of hand-held cameras and mass photofinishing.

The changeover from wet to pre-sensitized dry plates began in the 1860s, though the initial slowness of the newer dry plates held back widespread adoption for a number of years. In the 1880s George Eastman and his new company, Kodak, introduced film emulsions coated on paper. This novel arrangement allowed the film to be rolled up and placed inside a camera, where a transport system wound the film into place for each new exposure. After exposure, the camera and film were returned to Kodak for processing. When the prints were mailed, the customer also received a freshly loaded camera (similar to the so-called single-use camera of today).

The Kodak advertising phrase, "You push the button, we do the rest," became the cue for a massive picture-taking binge. Today, it's estimated that 3 billion pictures are made every year. It also is estimated that the number of snapshots stored in closets and shoe boxes around the world is approaching 160 billion.

Though snapshots make up the vast majority of these images, the professional and artistic practitioners continue to add to the legacy of the craft. Modern recorders of the human condition, including Nachtwey, Salgado, Richards, and Smith, have drawn upon the work of Fenton, Brady, Hine, and Lange.

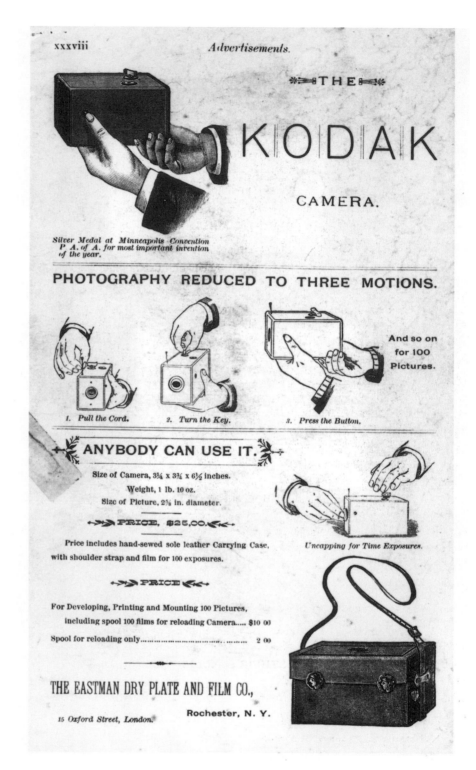

The marriage of photography and industrialism was inevitable, and the image as commodity became the engine of growth for companies such as Ilford, Eastman Kodak, and Agfa Gevaert. As photography became more convenient, the public appetite for participation in this magical pastime grew enormously. (Photo: Courtesy Eastman Kodak.)

Those who portray the artists and politicians of modern times, such as Newman, Karsh, and Avedon, have been inspired by Cameron, Genthe, Salomon, and Nadar. This wealth of imagery is available to us all in museums, galleries, and a host of monographs and retrospective publications.

ACKNOWLEDGING TECHNOLOGY

William Henry Jackson's adventurous images of the American West stirred the imagination of his generation, yet much of the effect of the images stems from the way in which they were recorded. Though similar in motif, the power and presence of Ansel Adams' landscapes have as much to do with his use of modern film, paper, meters, and filters as with his commitment to the land. And while Mathew Brady's battlefield scenes brought home the images of war, photojournalists such as Eugene Smith owed much to their equipment (imagine the record of the Civil War we would have if Brady had had a 35mm camera).

The vision of the best photographers always pushes the limits, transcending the equipment and materials at hand. Yet, each photographer's work is shaped by the traditions of the craft and the bounds created by the materials of the day. Photographers today enjoy greater convenience; the ability to make images under previously improbable or impossible conditions; and increased distribution of the image, including options for ever-faster communication.

The expressive nature of photography means that the images produced continue to be products of their age. Cameras and the techniques of photography have become even more automated; with technology so smoothly integrated, the users of the equipment are unaware of its complexity. Emerging technological developments hold promise for the art of photography, yielding images and modes of expression that will continue to fascinate and intrigue us.

Chapter 3

CAPTURING THE IMAGE: FILM, EXPOSURE, DEVELOPMENT, AND THE NEGATIVE

CAPTURING THE IMAGE: FILM, EXPOSURE, DEVELOPMENT, AND THE NEGATIVE

Film is the medium on which we capture images. The image is formed by light, and the amount of light needed to create the image is determined by making a light reading (the exposure) with an exposure meter. The amount of light entering the camera is controlled by the diameter of the lens aperture and the speed of the shutter as it opens and closes.

Once the film is exposed, it is then processed (developed) in a series of chemical baths. The result is a visible negative image. The brightness values in the scene are reversed in the negative image. In other words, light areas appear dark, and dark areas appear light. The negative image is made positive by projecting light through it onto a piece of photographic printing paper, which is then itself developed to create an image.

The negative is the intermediary between what is recorded and what we see on the final print. Though it may seem to play a supporting role, the negative is, in fact, at the crux of the whole photographic process. Proper exposure and development

Capturing a full range of tones on film is key in making expressive prints. The challenge here was maintaining separation between the wisps of water cascading down the rock face and the reflective surface of the rock itself. To emphasize the tonal play and accentuate the highlight separation, the edges and lower portion of the print were burned in. Obtaining these results with a less-than-full-toned negative would have been difficult, at best.

Fast films allow for handheld photography without flash under dim lighting conditions. Black-and-white film is the most tolerant of all photographic films under such conditions, as the problems of color imbalance do not distract from visual effectiveness of the scene. In addition, black-and-white films can be push-processed to speeds as high as EI 3200 with considerable success. This photo was made with Kodak Tri-X rated at EI 1600 and exposed at 1/30 second at f/5.6.

of the negative make printing a relatively easy task and give the greatest expressive freedom. However, if done improperly, visual information is lost, light quality suffers, and making even decent prints becomes a chore. The goal of exposure and development, then, is to obtain a negative with as much visual information and tonal richness as possible, given the lighting conditions at hand. The negative should mirror the relationship of the brightness values in the original scene, albeit in reverse.

There are many aspects to consider in the creation of negatives. Each aspect influences the look of the negative and, as a consequence, the success of the print. In this chapter we will consider film characteristics, exposure techniques, developing procedures, and special exposure and lab techniques that expand the possibilities for visual expression; as we explore each of these topics, we will

see how each can influence the final image—the print.

BLACK-AND-WHITE FILM
Speed

One of the main reasons for choosing a particular film is its *speed*. With fast films a photographer can work in dim light without using a tripod. It is with slow films, however, that the best possible image quality is usually attained. Many other film characteristics are determined by film speed as well, such as the film's grain, sharpness, and contrast.

Film speed is a relative measure of the sensitivity of the film to light. The speed is expressed by an ISO number. ISO refers to the International Standards Organization—a group that sets worldwide standards for such things. ISO numbers for current black-and-white films include ISO 25, 50, 100, 125, 200, 400, and 1000, with

speeds of 1600, 3200, and faster available with special "pushable" films. The majority of films available today are in the ISO 100- and 400-speed classes.

The relative sensitivity to light of each of these films can be figured quite easily, as the progression is arithmetic and the sensitivity halves or doubles with each halving or doubling of the ISO number. The lower the ISO number, the less sensitive the film is to light.

This halving and doubling of sensitivity matches the system of light control in the camera. Whenever the lens aperture is opened or closed one setting, or stop, there is a halving or doubling of the amount of light allowed through. For example, if you open up the lens one f-number, or stop, by going from f/11 to f/8, you double the amount of light. You can reduce exposure by half, or one stop, by increasing shutter speed from 1/125 second to 1/250 second.

This ability to choose relative light sensitivity through film selection allows photographers to match films to lighting conditions and exposure requirements. For example, suppose we are photographing the same scene with an ISO 50- and an ISO 400-speed film. The exposure reading for the ISO 50 film may be, for example, f/5.6 and 1/30 second. The reading for the equivalent amount of exposure on an ISO 400 film might be f/5.6 at 1/250 second, or f/16 at 1/30 second. The photographer's needs determine which exposure combination is appropriate. In some situations, a faster shutter speed is needed to stop action, while other circumstances call for a narrower aperture for greater depth of field.

Described as having three extra stops of speed, because you don't count the first number (ISO 50-100-200-400), the ISO 400 film does offer greater shooting flexibility. That's

why sports and news photographers generally choose faster film for their work. They often can't predict light levels, so they use fast film because it gives the greatest possible exposure leeway in whatever lighting conditions they encounter.

Grain

The previous discussion might lead you to assume that the best choice is always a faster film, regardless of lighting conditions or subject matter. The attraction of always being able to shoot at fast shutter speeds for greater camera steadiness and/or to work with the greatest potential zone of sharpness is tempting. But there is some trade-off to consider when choosing faster films.

While modern high-speed films are of excellent quality, slower films invariably have finer **grain**. Fine grain (and generally better sharpness) is one of the main reasons photographers choose slower-speed films over faster ones for subjects such as still life, portraiture, and architecture.

As mentioned in Chapter One, in the discussion on image formation, light-sensitive grains called silver-halides are reduced to metallic silver when exposed to light and developed. Greater light sensitivity, thus higher-speed film, is obtained by using larger-size grains in film construction. These larger light-capturing grains, however, are manifest as larger visible grains in the negative and become more apparent when the negative is enlarged to make a print. Grain becomes emphasized further if the

negative is developed longer than normal, or if the print is made on a high-contrast paper.

Grain is present in all film, with grain size directly related to film speed. Thus, to make an image with the finest grain, choose the slowest film speed possible. Keep in mind, however, that the choice of film is also influenced by lighting conditions and by whether a tripod will be used.

Advances in film technology have resulted in T (for tabular) grain films. These films have grains that are somewhat smaller and more light-efficient than the grains found in the older emulsion formulations. (Both types still are available today.) While T-grain films do offer finer grain in equivalent speeds when compared to the older formulations, the faster T-grain films are still grainier than slower T-grain films.

Some photographers do everything possible to reduce grain in their images. They shoot with the slowest speed films; they keep developing times to a minimum; they enlarge on low-contrast papers; and they use so-called fine-grain developers. (Use of these developers usually means exposing film at slightly less than the rated speed.)

Other photographers go the opposite route, doing whatever they can to enhance grain for graphic effects. You can boost grain by shooting with the fastest film available; by working with high-grain films; by overdeveloping film; and by printing on high-contrast papers. As the visual effect of grain is linked to the degree of enlargement (magnification), some

photographers either enlarge their prints to huge sizes, or take a specific area of the image and enlarge that section (a technique called cropping) to increase the image magnification even further.

Most photographers do not get obsessed with grain, as long as it doesn't get in the way of visual communication. There are those, however, who express the opinion that grain is an inherent characteristic of the photographic image, and that emphasizing grain stamps an image as eminently "photographic." Grain is used by other photographers for less lofty reasons, such as adding a nostalgic, mysterious, or even ominous note to an image.

High-grain films are those rated at ISO 1000; those that can be pushed to speeds at and beyond 1600; and infrared black-and-white film. If these aren't available, you can emphasize grain by developing any film in a highly active developer, such as a paper print developer, for about 1.5 minutes. This will yield a very dense but printable negative that has "popping" grain.

Contrast

Contrast in a scene is the difference between the lightest and darkest brightness values. Film itself has an inherent contrast, which is the way it renders brightness and the gray scale values it records. Films for general use vary only slightly in their contrast, though slower films do tend to be slightly more contrasty than faster ones.

More important to us than a film's inherent contrast, however, is the contrast produced on the negative by the way in which the film is exposed and developed. For example, if you underexpose on a bright day, the image will be more contrasty. Further, if you develop any film longer than normal, the image will be more contrasty. Controlling contrast that results from exposure and development is key to creating good negatives. We will cover this aspect in detail later in this chapter.

Contrast as recorded on film can also be adjusted by placing color filters over the camera lens. Filters pass and absorb certain colors. The color they pass is the color of the filter; they absorb or partially block all other colors, especially the opposite, or complementary, color. For example, if you want to deepen a blue sky and enhance the clouds, a yellow filter will block some of the blue and yield a slightly more dramatic look. Increasingly dramatic (blue and cloud) skies can be obtained by using a deep yellow, orange, or red filter, respectively. Some photographers will not do landscape work without one of these filters over the lens.

For extremely high contrast, some photographers use high-contrast copy films. Normally, these films are used to record documents and line drawings (thus record virtually no middle grays), and must be developed in special high-contrast developers. For special effects on pictorial subjects, however, it is best to record on conventional film and convert the full-tone negatives to high-contrast images

Black-and-white film is panchromatic, thus responsive to all wavelengths, or colors, of light. The film does, however, discriminate among colors somewhat differently than does the human eye. Shades of green may meld together, red may record darker, and blue may record lighter than it appears in the scene. Although it is not always necessary to shoot black-and-white film with color filters, some filters aid the faithful recording of colors, tones, and even details in certain scenes. In the top photo, the difference between the red and green peppers is not apparent. However, when a red filter is placed over the lens (center), the red records lighter than the green and is easily distinguished from it. This happens because the red filter passes red light and absorbs, or blocks, green light; thus the red peppers receive more exposure on film and print lighter in the positive image. To get the most detail from the leaf in the bottom photo, a green filter was placed over the lens during exposure, which helped to reveal every line and form within the leaf structure.

later. This gives the potential for more control and choice. These effects are discussed in detail in Chapter Six, Advanced Printing Techniques.

Resolving Power and Sharpness

Resolving power is, quite literally, the measure of a film's ability to resolve line pairs, which can be translated as an indication of its ability to record fine detail. The finer the line pairs resolved in a lab test, the higher the resolving power of the film. People mistakenly judge a film's sharpness based upon this test alone. Other factors play an equally important role, however, including film contrast and grain structure. There is also **acutance**, or tonal edge separation, or sharpness, which has a profound effect on the perceived sharpness of a film.

Most films for general photography are fairly equal in sharpness; however, as with other quality factors, the slower-speed films tend to look sharper than their faster counterparts. Of course, the way in which film is developed and printed plays a role, as does the sharpness of the camera lens used to take the picture, the steadiness of the photographer when the picture was made, and the sharpness of the enlarger lens used to make the prints

Format

Format refers to film size, or to the camera system which uses a given film size. For example, 35mm cameras use 35mm film; medium-format cameras use 120 or 220 film (with 6 x 4.5cm,

Figure 3.1

6 x 6cm, 6 x 7cm, 6 x 9cm, and other frame proportions); large-format cameras accommodate film sizes of 4 x 5-inches and larger (see Figure 3.1).

The size of the film does not change the film's characteristics, but it will affect the look of prints when enlarged. All things being equal, an 11 x 14-inch print made from a 120-size negative usually will appear sharper than one made from a 35mm negative. This occurs simply because the degree of enlargement (thus magnification) is less with 120 film than with 35mm film.

Despite their weight, bulk, and inconvenience (at least when compared with the 35mm), large-format cameras are used often by professionals. Large format delivers results demanded in the commercial market and often sought in the fine arts world. On the other hand, sports, news, and most of the illustrative photography used in publishing is made with 35mm cameras, as these

Infrared film can be used to render scenes in unusual ways, as part of the image record is from the near-infrared (invisible) part of the spectrum. To achieve the best effects, a red filter should be placed over the lens during exposure. Infrared black-and-white film has acquired cult status and is used by a dedicated group of photographers for landscapes, beach scenics, and even portraits. This film causes blue sky to become almost black, white clouds to fluoresce, and trees to glow. (Photo: Christopher Davies.)

are eminently portable tools that allow for spontaneous candid work. There is no fixed rule about using any particular format for any particular application, however.

Color Sensitivity

Most of the films photographers work with today are **panchromatic**, which means that they are sensitive to all wavelengths (colors) of visible light. Being panchromatic, all these films must be processed in complete darkness.

There are two other film types to consider: orthochromatic and infrared. **Orthochromatic** films are sensitive to UV and blue and green light; they are "blind" to red light, so they can be processed in a room illuminated (solely) by red light. This means that you can visually inspect the film as it is developing. Ortho films are quite oversensitive to blue and will "block up" (record as very dense) blue sky. Ortho film is used primarily for copy

work of documents and line art, or as a prime or intermediary negative (or positive) for special effects work.

Infrared films are responsive to all wavelengths of light, with a heightened response at the red/infrared (or visible/invisible to the human eye) edge of the spectrum. This film is made for scientific work, but professionals and amateurs also use it to give an ethereal, sometimes eerie look to images. A red filter placed over the camera lens is necessary for the best effect (this blocks out the UV, blue, and green light so the image is formed only by the red and infrared light). The result is a near-black sky (in areas of blue) with stark white clouds, glowing live subjects, and a feeling that the image was made in the light of an eclipse—in short, a most interesting film.

Reciprocity Effect

In photography, the **reciprocity effect** refers to the fact that when you do something you get a fairly predictable result in return. Give an additional stop of exposure, and a stop more density will record on film; add a certain amount of developing time, and density will increase in a fairly linear fashion.

Film/exposure reciprocity works within a commonly used range of exposure times. Expose at speeds slower or faster than that range and the reciprocity between exposure and density fails. For example, say a film has a range of 1/15 second to 1/10,000 second. Expose for 1/4 second and you might expect to gain two

stops of density (1/15 to 1/8 to 1/4 equals two stops); however, because of reciprocity effect, you may have to add another 1/2 stop to get a true two-stop gain of density (or the reciprocal effect of exposure) on the film.

The degree to which you must adjust exposure depends upon the film and the initial exposure time. Some films require as much as a two-stop adjustment for long exposure times. (For example, if exposure should be 20 seconds, you may underexpose unless you set the time for 80 seconds.) Manufacturers publish reciprocity effect and adjustment specs in film instruction sheets or accompanying technical literature.

Exposure Latitude

Exposure latitude is the amount of over- or underexposure that a film can tolerate and still deliver a printable negative. Of course, correct exposure is always best, and a negative that is extremely under- or overexposed will never yield an excellent print. But latitude is a type of forgiveness factor that makes everyone's photographic life easier.

There usually is a difference between the theoretically correct exposure and the exposure delivered by camera and film when working in the field. Variables abound in photographic practice and manufacturing, and not everything always works as it should. Exposure meters can be slightly awry; apertures may not be exactly as indicated; and shutters may speed up or drag a bit. Films may be more or less light-sensitive than

advertised, or a particular batch may be out of spec. The photographer may make exposure mistakes or process the film for less time than necessary or use slightly exhausted developer.

Hopefully, all these factors cancel themselves out, but if there is some imbalance, exposure latitude often comes to the rescue. Also helping the cause is the fact that black-and-white film has the broadest range of exposure latitude of any photographic medium; it has a considerably wider range than color slide film and a somewhat wider range than color negative film.

Latitude is expressed as a range of plus and minus from the "correct" exposure; generally, there's more leeway on the plus (overexposure) than the minus (underexposure) side. Though exposure latitude is fairly broad, however, a casual approach to exposure or development will cause you more trouble than it's worth. By following a few simple rules and allowing exposure latitude to cover variations in equipment and film, you will get negatives that will be easy to print.

Film Exposure

Exposure is the art of seeing, measuring, controlling, and sometimes manipulating light. Proper exposure is a balance of aperture and shutter speed that places the brightness values of the scene onto the recording range of the film in a way that allows you to easily make a print that mirrors the tonal variety and richness of the scene. The aim is to hold on to the light that you saw.

These negatives show the effects of over- and underexposure on image formation and negative printability. Although this is a contrasty scene, proper exposure (upper left) provides a good balance and rendition of tones. More important, it records most of the visual information in the scene. When overexposed (upper right), the shadow areas reveal details, but the highlights (brightest areas) become overly dense, thus "burnt up" in the negative. Although printing controls may help ameliorate this problem, the print may be harsh (when compared with one from the properly exposed negative) and will certainly be more difficult to make. The underexposed negative (lower left) has highlights under control but has lost shadow detail information. There is no way to bring this visual information back into the negative once it has been lost through underexposure. This negative can certainly be printed, but it will not have the tonal scale and information available in the properly exposed negative. Proper exposure yields a print that faithfully renders the tonal values and relationships in the original scene (lower right).

Though there is some leeway in making exposures (the latitude mentioned above), and there are some remedial steps you can take in printing to compensate for some degree of exposure error, print quality generally will suffer when exposure miscalculations are made. When film receives less exposure than is necessary, we say it is underexposed; this condition has a profound effect on the way we record the darker parts of the scene and on the negative's contrast. On the other hand, if too much light is allowed to strike the film, the negative will be overexposed. While usually less troublesome than underexposure, overexposure also adversely affects image quality and can result in loss of details in the brighter parts of the scene. In moderation, neither of these miscalculations is too serious. In extremes, however, these errors may be almost impossible to overcome.

Film itself also has certain limitations in the ways it can record light. These limitations must be appreciated and included in exposure calculations, as they will affect the difference between what we see and what we can record on film.

When light is recorded on film, it necessarily goes through some compression in tonal value (indeed, tonal value itself is an abstraction we impose upon the visual world). While the actual recording range of panchromatic black-and-white film is about seven stops (or a scene contrast in which the brightest and darkest areas are seven stops apart), the range in which we can successfully print is a bit more than five stops.

That is why we will usually use the five-stop range as a basis for our discussion in this text.

In general, concerns about recording range come into play only when photographing very contrasty scenes. You should note, however, that the *quality* of the light in the scene is of great importance. For example, if you're photographing a landscape and the light is tepid or flat, only a good deal of manipulation in printing will make even the best negative of that scene exciting. On the other hand, take the same picture on a day when the light is brilliant, or when directional light is illuminating certain areas of the scene, and you will have a more interesting negative and, thus, a stronger possibility of a better print. Capturing that exciting light may be a matter of patience or luck, but light quality determines whether a print will be memorable or ordinary.

A good exposure is one that faithfully renders the full tonal range on a negative and allows you to make a tonally rich print with ease. The key to success is knowing how to read exposure values and following up with creative decisions about how to apply those readings to the scene at hand. This scene offers a full range of exposure values. When testing film and your photographic skills, locate similar scenes with which to practice exposure techniques. Read the brighter values (represented here by higher, or narrow, f-numbers) and you will begin to see what separates the middle and darker values. Such tonal exercises will help you understand brightness values, tones, and zones and also how exposure and development link everything together.

Although there are printing techniques that can help you overcome exposure miscues or bring life to poorly lit scenes, the quality of light in a photograph is what makes stunning photographs. Patience, luck, and an eye for a certain quality of light are what make the difference between exciting images and mere documents of a place. Here, the light was changing constantly on this tree-topped ridge as the sun kept going in and out of the clouds. The exposure on each negative is the same, but the quality of light on the trees is different in each and adds detail and life to the scene. Which negative would you choose to print?

Reading Values

The range of brightness values in a scene can be easily read with your in-camera or hand-held meter. Set your shutter speed at a fixed value, say 1/60 second, and scan the scene with your meter. Suppose, for example, the darker parts of the scene read f/4 and the lighter parts read f/16. This is within a five-stop range; thus, all the brightness values can be successfully recorded on film and rendered on a print.

When metering, light is described in terms of highlight, middle values, and shadow. Highlights are the brightest parts of the scene, shadows the darkest, and middle values lie between. Highlights can be broken down into two main types that concern us here—the principal, or textural, highlight and the specular highlight. The **principal highlight** is the brightest part of the scene in which detail, or texture, is to be recorded. The **specular highlight** is simply bright tone (brightness) with no detail or texture. It may "read" on the print as paper white (the brightness and color of the paper base).

A principal highlight might be a white picket fence in which you want to show the grain of the wood, or an adobe wall in New Mexico that has been freshly plastered. This highlight need not be white; it is simply the brightest value you are recording with detail or texture. A specular highlight can be the glint of afternoon light off a lake, or the glare from a glass-and-steel skyscraper. There is no recording of detail in this tone—it is pure light, or bright white, in the print.

The other end of the brightness scale is the shadow. Here, you want to determine what is the **significant shadow** detail, or the darkest part of the scene in which you want to record visual information. There may be darker parts of the scene, but these will record as tone (deep gray to black), without textural information or detail.

Principal highlight and the significant shadow are important to consider when making exposures. While film does have a wide recording range, seeing the image in terms of a tonal spread and understanding how that spread will record on film are key to making good negatives. For example, say you are photographing a white car in bright sunlight. You take a reading off the white hood and roof and get f/16; you read the shadow cast by the car and get f/4. These readings present no exposure problem. However, suppose the tires on the car in the shadow area read f/2. This reading clearly is out of the five-stop range, so you must ask yourself whether it is important to record detail in the tire tread in this photo, or whether the tires can record as pure black (with no visual information other than tone). If you decide that the tires may record as pure black, the significant shadow detail will be the subject information in the shadow cast by the car. But if detail in the tire tread is significant to record, then other steps must be taken to record both the bright car and the tire tread. These steps may include the following: adding auxiliary light (fill flash); using a reflector card to bounce light

into the shadow area; or exposing so that the tires become the significant shadow area, then compensating for the overexposure of the highlights both in film developing and printing.

Later, we will explore how to make exposures under various lighting conditions using techniques such as those just described. Now, however, we will turn our focus to the instrument we use to measure light.

Exposure Meters

Photographers use an **exposure meter** to read light. There are two main types of meters—incident and reflected. Incident meters are hand-held (separate from the camera) and read the light that falls upon the subject. Reflected-light meters can be hand-held or built into the camera and read the light reflecting from the subject. All built-in meters are of the reflected-light type.

A meter measures light within a certain angle of acceptance, or coverage (see Figure 3.2). For cameras with built-in meters, that angle of coverage is defined by the lens on the camera (which in itself has an angle of view, or field coverage) and is modified by the metering pattern in use. These patterns range from an overall, center-weighted reading to a selective spot reading, usually defined by a circle within the center of the viewfinder.

Incident meters have varying angles of acceptance, depending upon the manufacturer, the model and how the meters are used. Generally, with an incident meter the reading is taken from the subject position with the

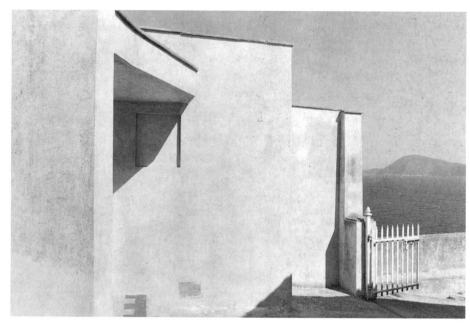

metering cell aimed back at the camera. Hand-held spot meters, which are all of the reflected-light type, read from a very narrow angle of acceptance, ranging from a high of 6 degrees to as narrow as 1 degree, or a very select portion of the scene. This allows for very select area readings, which are useful for critical exposure control.

Most cameras with built-in meters utilize a center-weighted averaging metering system (newer cameras add more options, but still retain this standard). This means that the light information used to calculate exposure is taken mostly from the center of the viewfinder, and the light values of the scene are averaged to arrive at an exposure. While some information is taken from the edges, usually it is not enough to sway the exposure too far in any direction (unless the light at the edges is extremely bright). Averaging will be discussed in more detail shortly.

CWA (center-weighted averaging) meters are reliable for most scenes of

When working with very bright and dark values, it is important to understand how to record those values on film accurately. Exposures that are off by as little as one stop can make the difference between holding or losing visual quality and information. In shadow areas, that one stop can make the difference between recording detail or just dark tones; in highlights, that one stop can make the difference between a bright value with texture and blank white—at the least, overexposure will result in a negative that is difficult to print. Here, exposing the bright wall properly was fundamental to the textural quality of the image. An exposure reading was made right off the wall, and the lens was then opened two stops, yielding a negative with properly placed highlight values that were easy to print.

Many cameras have built-in light meters coupled with computerized exposure programs. Although this level of automation has been a boon to photography, there are pitfalls of certain lighting situations that must be understood for best results. For those without such meters, or who may want more of a personal touch in exposure matters, handheld light meters are a good option. There are two types of handheld light meters. Incident meters (left) read the light falling upon the subject. Many incident meters also have flash-reading capability. Spot meters (right) are reflected light meters (such as the ones found in cameras) but can be used to make readings from very select portions of the scene. (Some high-end cameras also have spot-metering modes built in.) Black-and-white photographers who work in the Zone System or who want very selective tonal control consider spot meters a must. (Photos: Courtesy Sekonic RTS.)

Spot

Partial

Center-weighted
(shaded area shows
where most
information is gathered)

Evaluative matrix, etc.

Figure 3.2

average contrast (three to four stops difference between highlight and shadow), when the main subject is not backlit or highly reflective and when the light comes from behind the photographer and falls directly upon the main subject. This represents about 70 percent of most picture-taking situations. In other words, for such scenes, the photographer needs only to point a camera with a built-in metering pattern at the subject, put the exposure program on automatic (with whatever preference he or she has for balancing aperture and shutter speed settings), and shoot.

Spot, or restricted-angle, metering patterns can be used to take readings from very specific areas of a scene. In addition, spot meters are used to take multiple readings from distinct brightness areas. These readings are then used to calculate averaged exposures, or to "bias" exposures in certain ways. Spot meters or metering patterns in cameras should be used only when their workings are understood

and applied properly. Also, if you have a spot meter option in your camera, be sure that it isn't activated when you think another metering pattern is at work. Such a lack of awareness can result in poor exposures. The process of calculating averaged exposures will be discussed further later.

*What a Meter Does
with Light, and Why*

The purpose of the meter is to translate light values into aperture and shutter speed settings, the camera's light-controlling mechanisms. As the meter translates these values, it takes into account the light sensitivity of the film and matches or balances it with the scene brightness. The values the meter reads out (the exposure) are such that the range of brightnesses recorded will fall within the recording range of the film. It does this so that the tonal scale on the film mirrors the brightness values in the scene. The bright values record as

bright values (more density) and the darker values record as dark values (less density).

The meter aids in this process by averaging the light it reads to a middle gray, known as an 18-percent gray, which sits on the midpoint of the gray scale from black to white. This averaging "places" the various brightness values correctly on the film's recording range.

Most built-in camera meters do averaging and, for the majority of exposures and scenes, work quite satisfactorily. There are times, however, when meters are "fooled" by the light, or when the light is too contrasty to allow all the visual information in the scene to be recorded on film. This is when informed decisions will overcome the meter's failings, or when you will know that some of the visual information will have to be given up and recorded as tone without detail.

When a spot meter reads any brightness value, it converts that value to a middle gray. If it reads a white wall, it will record it on film (or assign an exposure setting that will make it record on film) as a middle gray wall. Likewise, a spot meter reading of a black wall will result in an exposure that will record that black wall as gray on film. If you point a camera with a built-in meter solely at these values, you will get the same results.

This may seem ludicrous, but actually it is quite helpful in allowing photographers to make creative decisions about how light records on film. As discussed previously, the aim of exposure is to get as full a tonal spread on

film as possible while still maintaining detail in the principal highlight and significant shadow. If we know where middle gray is, we know that the principal highlight is placed two to three stops brighter than the middle gray value. Likewise, we know that the significant shadow will record as such at two stops below, or darker than middle gray. This sets up the scale in which we can most successfully work and gives us a way to place values, or tones, within that recording scale. Thus, if middle gray is, say, f/8, the textural highlight will be placed at f/16, and the significant shadow will be placed at f/4. There may be some leeway from these values, but conceiving of exposure and value placement in this manner helps us visualize the way in which exposure and tonal value recording work together.

Ideally, when the CWA system meters, it averages and accomplishes this "tonal sorting." Overall, it does so effectively. In practice, however, it is not as precise as making select highlight and shadow readings with a spot meter. Consider, for example, what can trip it up.

Suppose we are exposing a subject against a bright white wall. We take a spot meter reading off the white wall and get f/16. This reading will record the white wall on film as a middle gray wall. We know we want texture in that white wall and want the wall to record as "white" on film (thus dense and dark in the negative), so we open up two stops to the reading (from, in this example, f/16 to f/8).

We then take a reading off the subject in front of the wall and get f/4.

Backlighting is a lighting condition under which the light from behind the main subject is quite a bit stronger (usually more than 1.5 stops) than the light illuminating the main subject. It is a classic fail situation for center-weighted, in-camera meters and is probably the cause of the majority of poor negatives. Backlighting is a major problem in landscape work, where the sky is often considerably brighter than the ground, and in portraits, where a subject against a bright background records quite a bit darker than intended. The key is to learn how a meter reads light and to understand when an exposure system needs your intercession. Once you know this, you can compensate accordingly or read select portions of the scene more carefully. Here, a backlighting failure shows the camera-recommended exposure, which resulted in the loss of subject information. The meter read and calculated exposure based upon the bright light behind the subject.

A simple test will reveal how an exposure meter works and the effect of exposure on tonal recording. Place a subject against a bright white wall. Make a reading of the wall (here, f/16) and expose at that setting (top). The wall will record as middle gray, and the details on the subject's face will fall into deep shadow or be lost. Next, make a reading off the subject's face (here, f/4) and expose at that setting (center). The face will be detail-rich, but the wall will become overexposed. Next, average the two readings (f/8) and make an exposure (bottom). This last negative maintains detail in the face while controlling the brightness of the wall. This averaged exposure balances the tonal rendition and makes for a very printable negative.

Because we want the subject to record with detail, but as darker than the white wall, we close down two stops (from the middle gray-rendition reading of f/4) and come up with f/8, the same reading that will give us a bright textured white. This is the average of the two readings (f/4, 5.6, 8, 11, 16 is the range, so f/8 is the average).

The CWA meter, however, might not have yielded that reading if we had pointed it directly at the white wall without taking the foreground subject into consideration. For example, if only the white wall had been read, middle gray would have been recorded at f/16. This would still allow us to print the walls as white (by using a higher-than-normal contrast-grade paper), but our subject, being four full stops underexposed, would not have recorded with detail. We would get only dark tones on the film, and thus on the print. Despite our efforts, no image information would be revealed in the subject.

This scenario describes the classic failing of in-camera meters—the failure of the person doing the reading to understand how the meter works. Just as you must know where to position a microphone in order to record a voice, you must know where to point the meter, whether in-camera or hand-held, in order to get the right exposure.

Metering Procedure

The keys to obtaining proper exposure readings are as follows: (1) know the metering patterns of your equipment and know how to use them; (2) know where to point the meter to include the principal highlight and significant shadow in the scene; (3) know that the meter is averaging to middle gray; and (4) know the lighting conditions that can cause problems and the ways in which you can compensate for them.

Conditions including high-contrast scenes, or those that are dominated by one brightness value, even though other brightness values are present, need additional work to get right. In the case of a very high-contrast scene, remember that film has a certain recording range beyond which it cannot go. It will record tonal values (or pure brightness or darkness), but not visual information within brightness values that are outside the recording range. This means that some visual information will be lost. How you make the reading and, ultimately, how you adjust the light values will determine which areas are lost and will get you the best results possible under the lighting conditions at hand.

Manipulating Light in Recording

You can make creative choices about how light is recorded from the scene onto film by moving around light values. In doing so, you can work to get as much visual information and tonal richness on the negative as possible, or you can eliminate certain values for graphic effects. Though it's usually best to aim for the former result, the ability to juggle recorded tonal values is a key creative element in black-and-white photography.

As discussed, meters average to or read values as middle gray. If you meter off a bright area in a tonally

varied scene, the bright areas will record as middle gray and the darker areas will be compressed down into darker and darker tones. Conversely, if you meter and expose for the darkest area in the scene, the brighter areas record brighter on film and may be driven up into overexposure. Think of the tonal scale as working in lock step, with the ability to record a range of values as having a fixed spread that can be moved up and down the gray scale.

Having reached this understanding, the concept of light manipulation should begin to make sense. As mentioned, you can read only from a bright value and record that as middle gray, with the darker areas losing detail and becoming dark tones. Or, you can read the bright value as middle gray and then compensate exposure by opening up two stops; thus, the brighter value will record as bright with texture and visual information on the film. Another alternative is to open up three or more stops and have that value record as bright, textureless tone. (For example, plus two would keep the texture of wood in a picket fence; plus three or more would give you pure, driven snow.)

Conversely, you can read the significant shadow value and have it record as middle gray, which will make the brighter values record brighter still or, perhaps, become overexposed. You can also read the dark value as middle gray and close down two stops to have detail recorded in that dark value. Another choice is to use that same reading, close down three stops, and get a deep tone

with virtually no visual information. In these ways you control what is recorded with detail, and what records as dark or bright tones without detail, on the negative. Compensation is not limited to working with two stops—you can manipulate values by one stop or by half stops if that serves your purposes.

This strategy gives you control over highlights and shadows and how the scene you see will record on film. Once you understand and appreciate the concept of value and tonal manipulation, you can shape an image in a variety of ways. For example, you can have bright areas record just as bright light, or with texture and detail. Dark areas can be recorded as a shade of deep gray with details, or as deep black shadow. Through exposure you determine how the brightness values record on film, and whether those values will carry information or simply be a bright or a dark tone. This decision-making process continues when prints are made, a topic we will cover in the next chapter. To further illustrate this concept of manipulating light through exposure, the following examples of light reading address varied lighting conditions. In each case we are maintaining a constant shutter speed and using the aperture as the variable control.

Average scene contrast: significant shadow reading, f/4; principal highlight reading, f/16. This is a straightforward scene that the CWA meter will handle well, as long as both values are taken into consideration. The meter reads the values and averages

them to f/8, which places the highlight and shadow in the correct place on the scale within the recording range of the film. If a spot meter is used, the highlight and shadow area will be read, then averaged to f/8.

The main pitfall here occurs if one of the two values dominates. If the shadow area is only a small portion of the scene (such as a small dark object against a white wall), the meter may pick up only the f/16 value and make that middle gray, which would drive the darker object down into dark tone with no detail. The converse also applies. Keep your eyes open to this possibility; solving the problem will become instinctive after a while.

Low scene contrast, low light: readings of f/4 and f/5.6. This scene also is no problem, as the meter will take whatever values there are to middle gray. Though this may record the values brighter than they actually are in the scene, it will make for a negative that's easy to print. If the values are "flat" (very little or no contrast), you may want either to overexpose by one stop or, if the entire roll is exposed under the same lighting conditions, develop the film 20 percent longer than the normal developing time. Both courses will raise scene contrast and give you a more lively negative to print.

Low scene contrast, bright light: readings of f/11 and f/16. Bright scenes can be low in contrast as well. An averaged exposure will bring the brighter values to middle gray, which will yield a printable negative. You

could also move the brightest value to the higher end of the recording range by taking the f/16 reading and then opening up two stops (to f/8), thus gaining more density on film. As you gain experience in printing you will understand the implications of both actions and choose accordingly. Both choices will yield printable negatives, though the latter will make it simpler to make a good print on a normal contrast grade paper.

High scene contrast: significant shadow reading, f/2; principal highlight reading, f/22. This range of contrast presents a problem and demands the most attention. Averaging will not help, as an exposure that falls between f/5.6 and f/8 will result in the loss of shadow detail and overexposure of the highlight. (However, the highlight could be "burned in" when printing, though some loss of quality may result. This is discussed in Chapter 6.) If you expose to place the shadow detail in range (f/4 to f/5.6), the highlight will be quite overexposed (very harsh); expose to place the highlight at two stops above middle gray (f/11), and the shadow areas will be plunged into dark tones with no detail.

There is one technique that can make the best of this very difficult contrast range. It involves exposing for the shadow detail and decreasing the film's developing time (see "Pull Processing" in the developing section to follow). Here, you meter the significant shadow detail and then close down two stops (read f/2 , expose at f/4 or between f/4 and f/5.6). Do not meter only for the

significant shadow area and then do nothing—a common mistake when people follow the "expose for the shadow, develop for the highlight" maxim that is often invoked as a remedy to very contrasty scenes.

Exposure Tips

While exposure is very important to successful photography, modern metering systems make it a fairly simple matter, given an understanding of the way meters work. Photographers tend to get very agitated about exposure metering and often allow calculations to get in the way of their inspirations. Film and light interact in a fairly predictable way, so looking at the light and thinking about how it will record on film will eliminate most problems.

To summarize exposure, here are some tips:

1. Film can't record the way your eye sees, but that doesn't mean you can't record the quality of light in a way that makes for a beautiful print. By manipulating exposure, you can create a heightened sense of light often unseen by the naked eye.

2. Most scenes are less challenging than you might imagine. In-camera and hand-held meters, when used with understanding, deliver virtually all the information you need. When uncertain, meter for the most important subject in the scene and manipulate the other values around it. When in real doubt, bracket exposures (make exposures plus and minus from the calculated reading).

3. Meters are made to deliver an aver-

age of light values in a scene and to average those values to a middle gray. When properly metered and exposed, brighter areas record bright and darker areas record dark. The photographer controls exposure by taking readings from the principal highlight and the significant shadow area in the scene and then placing those values within the film's recording range.

4. Even the best photographers make mistakes or work in situations in which tricky lighting conditions challenge them. Film latitude helps, as does the ability to correct some mistakes in printing. In fact, some of the best images result from mistakes or from creative interpretation of the light. Recording as full a tonal range as possible usually is best, though creative interpretation of a scene in the negative stage also can yield wonderful results.

FILM DEVELOPING

Once a film has been exposed, it must be developed to make the recorded latent image visible. Though there are many labs that can handle this for you, developing your own film will give you the most consistent results. If you defer to a lab, use a custom lab recommended by your peers, and test it with a few rolls before you commit any important work to it. Do not simply drop your film off at a drugstore or camera store and expect decent results. Inevitably, you will be disappointed.

Before we discuss developing, however, let us first consider safety in dealing with all chemicals. Do not eat or drink around chemistry; keep

chemicals out of the reach of children or the uninitiated; work in a well-ventilated area; wear disposable gloves when mixing or handling; and read and understand precautions and antidotes that come with the packaged chemicals. In short, use common sense and care.

Black-and-white film developing is quite simple—film can be processed in as little as fifteen minutes, and multiple rolls can be processed at the same time. There are four main steps in film developing: the developing bath, which creates the visible image (tones and visual information); the stop bath, which halts the developing process; the fixing bath, which removes unexposed silver halides and prevents further exposure when the film is taken into the light; and washing, which removes residue chemicals from the film.

There are over thirty different developers available from numerous manufacturers. Each developer has its attributes. Some deliver high-contrast results, while others claim to deliver the finest grain or the sharpest images. The simplest way to find the right developer for your work is to test. Work with general-purpose developers first (Agfa Rodinal, Edwal FG-7, Ilford ID-11, Kodak D-76 and T-Max Developer, to name a few), and then branch out into special-purpose mixes later. Each photographer has his or her favorite, which he or she defends with some vigor.

You need not match a certain brand of film to the brand of developer because many of the formulas are quite similar. Off-the-shelf developers work fine and are manufactured with excellent consistency. Liquid concentrate developers are easier to mix than powder formulations, as you can mix just as much of the liquid as you need for each run of film developing. While you should experiment as you wish, do arrive at a film/developer combination and stick with it. This is one important way to make developing a consistent, routine part of creating the image, as it should be.

You can work with either a stock solution of developer (mixed to its working strength) or, with many developers, with a ratio of 1 part water to 1 part stock (known as 1:1). Dilutions of 1:1 are used for economical reasons (though some argue that dilutions yield finer grain, as well). Keep in mind, however, that when working 1:1 you must develop for longer periods of time.

Agitation of the film during processing is very important. This brings fresh chemistry into contact with the film throughout the cycle. Agitation involves rotating the developing tank side to side, first clockwise and then counterclockwise, while holding it in your hand. It is done gently, in a smooth motion and at regular intervals throughout the process.

Finally, charts supplied with chemistry showing developing time and temperature recommendations for different films should be taken only as suggestions. In general, the times given by manufacturers are too long, in this photographer's experience, and testing is critical to success (a simple test for arriving at the best time for your needs

is explained at the end of this chapter). See Figure 3.3 for guidelines on determining developing times.

The second step in processing is the stop bath, which is a dilute acid solution. Some photographers who object to the acrid smell use a water bath instead. Although this does not halt the developing process as abruptly as does an acid bath, it does work.

Fixer, the third step, comes in two varieties and with and without a hardening component. Standard fixer takes a bit longer than rapid fixer (about two or three minutes more), but rapid fixing baths must be carefully monitored, as overfixation will mean longer wash times and, in the extreme, a bleaching of the image. Hardener toughens the film emulsion and is essential in film processing. You can buy a hardening fixer or add hardener as a separate component. The same chemistry for fixing is used both in film and print processing (with a slightly different dilution); however, hardener should not always be used in print processing. That's why buying fixer without hardener, and then adding it when needed for film processing, is the most economical course.

The wash step, which follows fixing, is very important, as any fixer left in the film will cause damage later. Over time, fixer will combine with sulphides and other air pollutants and cause staining and fading of film. In fact, the chief cause of black-and-white image fading and staining is insufficient removal of fixer due to poor washing.

Fixer is removed by washing in combination with a wash-aid step.

Figure 3.3

DETERMINING DEVELOPING TIMES

For each film, developing time varies with the type of film developer used. Check the film instruction sheets for the suggested time and use that as a general guide to determine the period of time that will give you optimum negatives. Here are some suggested film developing times for some Kodak black-and-white films. Time, in minutes, for film processed at manufacturer-suggested developing temperature. Note that recommended temperature for T-Max developer is 75-degrees F; for all other developers it is 68-degrees F.

Film	Developer	Manufacturer-suggested developing time (minutes)
T-Max 100 Professional	T-Max	6.5
T-Max 100 Professional	D-76	9.0
T-Max 100 Professional	HC-110(B)	7
T-Max 400 Professional	T-Max	6
T-Max 400 Professional	D-76	8
T-Max 400 Professional	HC-110(B)	6
Tri-X Pan	T-Max	5.5
Tri-X Pan	D-76	8
Tri-X Pan	HC-110(B)	7.5

This hypo (another word for fixer) clearing bath makes the fixer more soluble in water. Fail to use a wash aid, and wash times become excessive, stretching to over an hour. By using a wash aid, the final wash time can be as short as twenty minutes.

All developing must be done in complete darkness. The only step that you must complete in total darkness, however, is loading the film onto developing reels. These reels are then placed in light-tight developing tanks, which allow you to complete the remainder of development in room light. You can even load film onto reels in subdued room light with a "changing bag," a contrivance that forms a light trap around your hands

Developing time has a major effect on negative density and quality. Overdevelopment increases contrast and thus alters the tonal balance; underdevelopment weakens tonal richness and can make for poor contrast rendition. This set of negatives, all made at the same exposure, shows the effects of ever-lengthier development times: the times are 7, 10, 13, and 16 minutes, (top left, bottom left, top right, bottom right). Note how the highlight density increases as time increases, with excessive contrast resulting from longer developing times. Note also how the shadow detail fails to increase proportionately, even with extended developing times. Shadow detail is affected by exposure, while highlight density builds with increased developing time.

and forearms. This takes some practice, but it's handy for working while on the road. If you are working with large-format sheet film, you must develop in trays or deep tanks in complete darkness for the entire cycle.

Time and Temperature

Before we describe the developing steps in detail, we should briefly consider time and temperature. Like all chemical reactions, developing is affected by the duration of the process and the temperature at which the reactions take place. Even a small change in one of the factors will cause a change in results. This makes for unpredictability and can eliminate all the care taken in exposure.

Generally speaking, most photographic processes are geared to work best at room temperature—between 68- and 70-degrees F. Some films, such as T-grain films, are best processed between 70- and 75-degrees F. Temperatures higher than 78-

degrees F will cause unpredictable results with almost every film; conversely, working at temperatures colder than 60-degrees F will slow reactions to the point of ineffectiveness, and no amount of time compensation will make up for such cold working temperatures. See Figure 3.4 for information about the effect of temperature change on developing time.

Materials Needed for Film Developing

The tools you will need for film developing include developing tanks and reels, a thermometer for checking temperatures, beakers and jugs for mixing and storing chemicals, a pair of scissors, and a bottle opener. Tanks and reels are made of either plastic or stainless steel. The plastic types are of the "walk-on" variety, which means film is led onto a guide and then is easily loaded by rotating the reel between your two hands. The metal reels are somewhat more difficult to

load, as there is no guide other than your fingers for loading. The stainless steel variety, however, does tend to be more durable and is easier to clean. Practice loading the reels with blank rolls before you work with an exposed roll of film.

Use the bottle opener to open the film cassette. The scissors are then used to cut off the film leader, or "tongue." The film end should be cut in a half-moon shape before loading.

THE DEVELOPING CYCLE

1. In a totally dark room, load the film onto reels. Make sure the film does not "jump" the guides, as this will cause the film to overlap and prevent chemistry from getting to the covered areas.

2. Place the loaded film into the developing tank and secure the lid. You can then continue the process in room light.

3. Prior to developing, mix all the necessary chemistry, making sure that the temperature is correct. Use a needle-nose thermometer to check just before developing. Keep chemistry in separate measured containers; these can be kept in a tempered water bath to maintain their temperature.

4. Open the lip of the tank top (the inside will remain light tight) and pour in the developer. Set the timer

Figure 3.4

EFFECT OF TEMPERATURE CHANGE ON DEVELOPING TIME

Developing, like all chemical reactions, is affected by the temperature of the solutions used in the process. Failure to control temperature will have an adverse effect on results, while changes within the temperature parameters change the developing time. The chart below shows the effect of temperature changes on developing times with a group of Kodak black-and-white films developed in Kodak D-76 developer.

Film	Temperature	Recommended developing time (in minutes)
T-Max 100 Professional	65	NR*
T-Max 100 Professional	68	9
T-Max 100 Professional	75	6
T-Max 400 Professional	65	NR*
T-Max 400 Professional	68	8
T-Max 400 Professional	75	5.5
Tri-X Pan	65	10
Tri-X Pan	68	9
Tri-X Pan	75	5.5

*Not recommended

for the developing time. (We will use a seven-minute developing time for this example.)

5. 7:00: When the tank is filled, hold the tank in your hand and turn it first clockwise, then counterclockwise in a steady, twisting motion. Do not shake it too hard. After 30 seconds of agitation, tap the tank against the counter; this frees any bubbles formed during the initial agitation. (The time is 6:30 after the first agitation cycle.)

6. 5:30: Give a 10-second agitation. Agitate again at 4:30, 3:30, 2:30, and 1:30 for 10 seconds each time.

7. :30: Perform the last 10-second agitation. When you are finished, open the light-tight lip (not the tank top!) and pour out the developer.

8. Pour the shortstop or water bath into the lip of the tank top and replace the lid. Agitate for 30 seconds, then empty out the shortstop.

9. Pour the fixer into the lip of the tank top, close the lid, and agitate for 30 seconds. Follow the recommended fixing time, and use the same agitation schedule used in the developer step (10 seconds of agitation every minute). When that cycle is finished, empty out the fixer.

10. Open the top of the tank and wash the film on the reel in a vigorous water bath for five minutes. Use a film washer if available.

11. Empty the tank or use another container with a solution of wash aid (hypo-clearing solution). Agitate as indicated in the wash-aid instructions.

12. Wash the film on the reel for about 20 minutes, then remove the film from the reel. Hold the film on both ends and run it through a wet-ting agent bath, such as Kodak Photo-Flo (this prevents water spots from forming during drying). Hang the film to dry in a dust-free area.

13. When the film is thoroughly dry, cut it into strips and place the strips into a protective film file page.

In most cases, black-and-white chemistry can be poured down the drain with a running water flush. If you are a heavy user of chemistry and are concerned about dumping it, however, investigate ways to reclaim silver from the fixer. Check with photo manufacturers on disposal plans, as most offer extensive literature on the subject.

Push Processing

There may be times when you do not have sufficient film speed to get the exposure you need under the lighting conditions at hand. For example, you may be shooting indoors at a sports arena and need faster shutter speeds to capture the action. Or, you may be photographing in a nightclub where the performer is lit by low light and you can't use a tripod to steady the camera during long exposure times. This is when a technique known as push processing comes to the rescue.

In push processing, a photographer deliberately underexposes and then compensates by overdeveloping. You do not change the inherent film speed by pushing; rather, you extend developing time to add more density to an underexposed image. The highlights will pick up more density than the shadow areas when you push process. (If shadow details are under-

Push processing is deliberate underexposure compensated for by overdevelopment. The actual speed of a film cannot be altered, but, as we have seen, we can add density to the highlights through extended developing times. Here, concert lighting and handheld use of a telephoto lens necessitated push processing. An ISO 400 film was rated at EI 1600, which gave two more stops with which to work. The film was pushed two stops by doubling the normal developing time. (Photo: Grace Schaub.)

exposed to the point of recording tone but no detail, however, no amount of pushing will bring in those details.) That's why pushed film is always more contrasty. In addition, grain increases when you push.

Here's how pushing might work: You have a 400-speed film in your camera, but when you take a reading you find that you need two more stops to get the photo you want. You set the ISO speed on the camera or meter to 1600. Naturally, anything you shoot on that roll will be two stops underexposed, but you can now capture the action.

You consult the time and temperature charts for the film/developer combination you are using and see that, for example, a two-stop push requires an extra 8 minutes of development. If your normal developing time is 6 minutes, the pushed time would be 14 minutes. You should be

aware that published push times are not always precise, though. You must test the film you work with to achieve the results you want.

While there is certainly some quality loss with pushing, often it is better to have a bit less quality than to lose the picture. There are certain fast films that are manufactured for pushing, and you can attain fairly good results at speeds of 3200 and even 4800. As of this writing, Kodak T-Max P3200 and Fuji Neopan 1600 are two such films. Note, too, that when pushing the entire roll must be exposed for the same speed and developed for the same amount of time.

Pull Processing

The opposite of push processing is pull processing. This is deliberate overexposure that is compensated for by underdevelopment. Pull processing is used mainly in very contrasty lighting situations. As discussed in the exposure section, there may be times when scene contrast is so great that the recording range of the film limits your ability to encompass all the brightness values. In this case, you bias toward the significant shadow detail (metering it, then closing down about two stops) for your exposure, which overexposes the highlights. If developed normally, this would make for a very harsh, difficult-to-print negative.

When you pull process you actually retard the highlight density buildup somewhat, while making sure the significant shadow areas record properly. Most pull developing times range from 10 to 20 percent less than normal developing times, depending upon the severity of contrast. Whatever length of time you settle upon (again, testing is key), make sure the final developing time is not less than about 3 minutes or the results will be poor. Finally, as with push processing, the entire roll must be exposed and developed in the same way.

TESTING FOR THE BEST DEVELOPING TIME

All photographers expose and develop somewhat differently, looking for different qualities in their negatives. These unique approaches result in different visions and interpretations. Yet, this does not mean that developing is or should be imprecise; it is more an appreciation of each of our foibles, our different techniques, and, often, our imprecise equipment. You can optimize results for your way of working by customizing your developing time and procedures for every film/developer combination you use.

Testing also will give you practice in reading negatives and finding the optimum contrast and density for your way of making prints. This does take some time to master, but coordinating your negatives with the type of prints you desire is the best approach. You may find too, that certain negatives yield better results with different light sources in your enlarger. In general, photographers who print with a condenser head seek negatives with a bit less contrast than those who print with a cold light head.

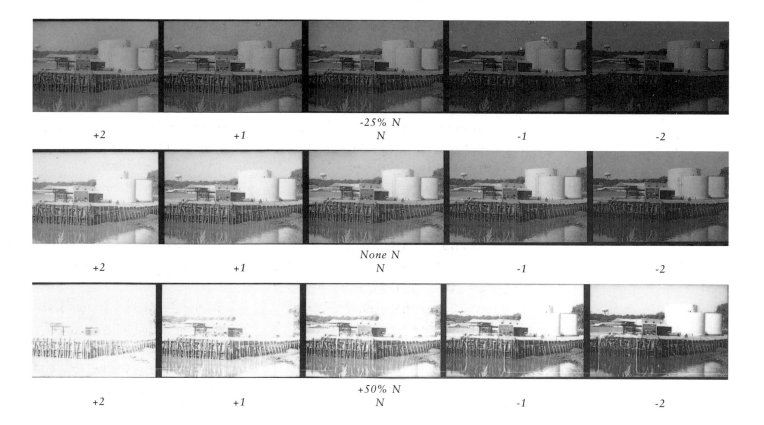

-25% N
N

| +2 | +1 | N | -1 | -2 |

None N
N

| +2 | +1 | N | -1 | -2 |

+50% N
N

| +2 | +1 | N | -1 | -2 |

Though this photographer has found that most film manufacturers' charts recommend longer developing times than necessary, they do give a framework within which to experiment with developing times. Thus, when doing the following test, use as your base time that recommended by the manufacturers' charts.

The test requires that you expose film of a scene that has a four- to five-stop contrast range. If you are working with 35mm film, you can do this test on one roll of film. If you work with 2-1/4 film, you will need three rolls of film to complete the test. Finally, if you are working with 4 x 5 film, a minimum of fifteen sheets will be required.

First, read the scene to average the exposure and make the averaged reading fall on f/8. Keep the shutter speed locked for all subsequent exposures, using aperture settings as your exposure variable. Bracket exposures +/- 2 stops; your sequence will be f/4, f/5.6, f/8, f/11, and f/16. You will end up with five full bracketing sets on one roll of 35mm 36-exposure film. For 2-1/4 film, expose as many bracketed sets as possible on each of three rolls. For 4 x 5 film, expose each sheet with an aperture shown in a test card in the picture itself and sort the holders carefully.

The following describes procedures for 35mm film. If you are using 2-1/4 film, develop each roll individually without cutting. For 4 x5 film, develop one bracketed set at each of the times indicated.

In a totally darkened room, unload the film from the cassette and fold it over itself so that you have

The "ringaround" test both yields the optimum developing time for your work and gives you a visual catalog of the effects of varied exposure and development times. Do this test for each film/developer combination with which you plan to work. In the underdeveloped set, note how underexposure and underdevelopment combine to cause a loss of image information and tonal richness (top); conversely, note how overexposure and overdevelopment yield a harsh negative (bottom). From all the possible combinations, pick the negative that "reads" best and provides the fullest visual information. Adjust your exposure/developing time if necessary (see text). In this set of negatives, the normal/normal negative (center) comes out best; thus, this combination of exposure and development used tests as the optimum with which to work.

three equal lengths of film, which you will cut. Load each length onto a different reel and place each in a separate tank (if you have only one tank, secure the remaining strips in a light-tight container). Develop one strip at the recommended time, one for plus 50 percent of that time, and one for minus 20 percent of the recommended developing time. When dry, cut the strips and place them into negative file pages, identify each developing time on the page and the exposure sequence on the strip of negatives.

This creates a catalog of exposure/development results—normal exposure and normal development, underexposure and underdevelopment, overexposure and overdevelopment, underexposure and overdevelopment, and so forth. Inspect the negatives and, on the file page sleeve, cross out those that are obviously too harsh (with overdense, unreadable highlights) or too weak (where significant shadow details are not visible). Identify those that have a full tonal spread and that, to your eye, reproduce the scene faithfully.

The final stage of this test is making a contact sheet to verify which are the best negatives. Printing will be discussed in the next chapter, but keep in mind that the best negatives are those that will yield a full tonal rendition with sufficient detail in the highlight and shadow areas on a #2 contrast grade paper. If the "normal-normal" negative (exposed for the averaged reading, f/8, and developed for the recommended time) turns out best, then you can follow film/developer manufacturer recommenda-

tions. But if the "normal (exposed at f/8), minus 20 percent developing time" negative is best, you know that you should cut back on your developing time in the future. If the "plus one stop, normal developing time" is best, you can either change the rating on the film when shooting in the future, or you can increase your developing time slightly. Finally, if the "plus two stops, overdevelop 50 percent" frame is best, check your equipment.

This simple test can save you much frustration, as it pinpoints the film/developing time combination that's right for the way you work. You should perform this test for every type of film with which you work. (To check their equipment, some photographers also do this test with every camera they use.) You can also perform this test for push and pull processing, helping you to get optimum results when developing times must be altered to handle low or harsh lighting conditions. To excel as a photographer, then, you must expect to spend some time testing the materials to get the best from them for the way you see and work.

Having discussed exposure and development of negatives, we can proceed to the next stage of the craft where the photographer's work comes to fruition—making prints.

THE PHOTOGRAPHIC PRINT

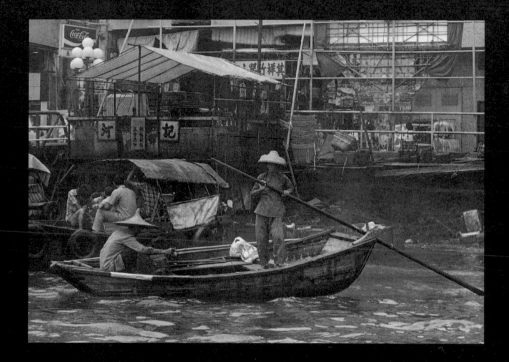

The print is the culmination of the photographic process. In printing, interpretation and creative expression reach their greatest height and demand the most critical visual decisions. As with exposure and development, an understanding of the fundamentals leads to the greatest creative freedom. Keep in mind, however, that techniques are used to serve the image and to enhance communication—not as an end in themselves.

Prints are made by exposing the negative image onto specially made photographic printing papers. There are a host of papers from which to choose, with various surfaces, image colors, and, most important, contrast grades. There are many ways to work with these papers, as they are subject to both light and chemical manipulations. In this section we will explore the materials used for printmaking, including papers and darkroom equipment. We will also discover the basics of making prints and how to attain a good "straight" or full-toned print. In the sections that follow, we will explore more interpretive approaches to printmaking.

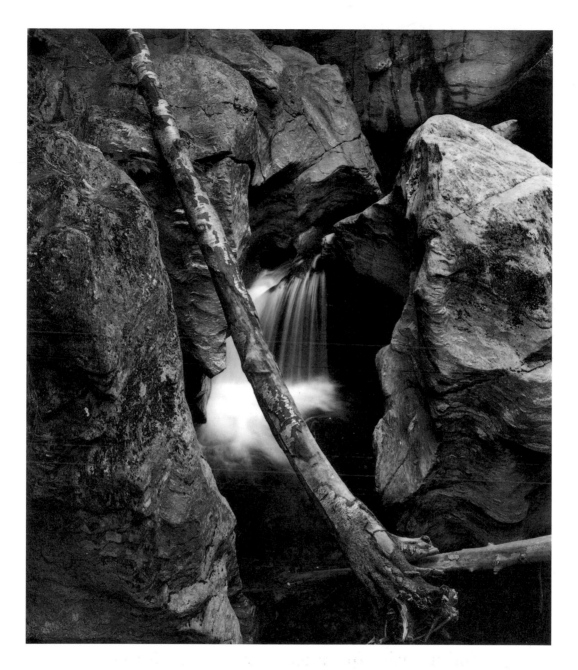

The final print brings into play all that went into creating the image, including visualizing the desired look of the water flow and selecting an appropriate shutter speed, exposing so that the subtle shadow details were faithfully recorded, and printing on a #2 grade paper to display the full tonal range offered by the negative. (Photo: John Schaub.)

One of the joys of printing is that there is no single, predetermined way to do it right. The printer has creative choices in virtually every step of the process. However, this creative freedom does not mean that the printer can approach the work haphazardly, or with no understanding of how or why certain results can be obtained. That's why knowledge of the basics of printmaking is essential to exploring personal and visual possibilities. Each printer should build a foundation of knowledge by learning how to make a good straight print before greater interpretation becomes valid. By gaining an understanding of the elements of a good print, you will become a better photographer, because you will learn to see the potential of an image before you record it on film. This knowledge will also bring you full circle, in that you will begin to understand what it takes to make that vision manifest.

This circular reinforcement of vision is key to the art of photography and is attained through time, trial, and an understanding of how exposure, development, and printing should be handled. Before we address actual printmaking techniques, however, we will explore some of the main characteristics of printing papers. As you will see, choosing a paper has a profound effect on the final image.

PRINTING PAPER CHARACTERISTICS

Image Support

There are two main types of photographic printing stocks—resin-coated (known as RC) and fiber-based (which we will call FB). The image emulsion on RC printing paper has a plastic or polymer overcoat, while the FB emulsion has a paper support. The differences between the two are many, as are their practical uses. RC papers are more convenient to process and dry; when speed is critical, RC is the appropriate choice. Most people use RC for proof prints, press prints, contact sheets, and prints that are primarily made for reproduction.

FB papers are the preferred choice for gallery and exhibition prints, portfolio prints, and any prints where image stability is more important than processing convenience. Although the quality of RC materials has improved substantially over the past few years, the preference for FB materials for fine art work remains. Part of this is due to the fact that, when processed properly, FB materials have better long-term stability than RC materials.

Surface

There are numerous surface textures from which to choose in both RC and FB stocks. Glossy is the most popular texture, as it allows the full tonal richness of the image to come through. RC glossy dries to a smooth, "hard" sheen, even when air dried. For best surface finish and print quality, RC papers should be dried using a special RC infrared dryer. For many uses, however, air drying is fine.

For FB prints to have a hard sheen, they must be dried using a

device known as a ferrotype plate. In this drying technique, heat is applied to a print that sits between a cloth "apron" and the metal plate. Many printers prefer FB glossy air-dried, which eliminates the hard sheen, yet allows the richness of the image to come through. FB prints can be dried using special racks, blotter sheets, and/or books available in camera stores. Note, however, that if the FB print is not flattened or restrained from curling during drying, it will prove difficult to flatten later.

Matte surface prints have no surface reflectivity, giving a buff, eggshell-like appearance to images. While some printers consider matte prints dull or lacking in rich blacks, they are recommended when retouching or oil coloring work is to be done on the print later. The matte surface also seems to work well with high-key images, that is, those with a tonal scale between light gray and pure white.

There are a number of other surfaces available, including a light stipple and heavy "weave" texture. For the most part, these papers are used for portrait prints, or for retouching or coloring. Paper manufacturers offer sample books with all their available papers. To obtain a sample book, write the paper manufacturer or inquire at a camera or professional photo store. Some manufacturers offer sample packs that contain a few sheets of their various stocks. Though most printers work with glossy stock, do experiment with other surfaces to see how they suit your creative needs.

Image Color

Though it might seem odd that a monochrome medium has an image color, close examination of black-and-white prints will reveal a definite color cast. Often, this cast is referred to as tone, with papers described as "warm," "cold," or "neutral" in tone. These terms have nothing to do with temperature, referring only to color cast. This cast is subtle, but definitely noticeable when one type of paper is placed alongside another.

In general, cold papers have bright whites, neutral midtones, and near-blue blacks; warm papers have creamy whites and near-brownish blacks; neutral papers tend toward the cool side, but the blacks have virtually no color cast. These divisions are not always clear-cut, however, and one paper manufacturer's neutral tone may look more like another's warm tone, and so forth.

The developer used to process the paper has a definite effect upon image color; in fact, even the temperature and age of the developer can affect the color cast. So-called "warm-working" developers (such as Kodak Selectol) will enhance the brownish cast of warm-tone papers or neutralize cold-tone papers somewhat. Indeed, some developer print combinations are less than desirable; for example, a "cold-working" developer (such as Kodak Dektol) may create a greenish-black when used with certain warm-tone papers.

The choice of paper tone can have an emotional effect upon the image. Compare how a portrait looks on a

warm- and a cold-tone paper. How is the character of the subject changed? Print a landscape on a neutral tone paper, then on a warm tone, and compare the difference in the sense of place. Experiment with matching, and mismatching, developers with various image color papers to gain appreciation for the many options available to photographers.

Weight

Paper weight refers to the thickness of the base support. Virtually all RC stock is medium weight, which means that it will stand up to all but the greatest stresses during processing and handling. FB stock weight ranges from light to premium weight. Sometimes called "A" weight, light stock is about the thickness of type-writer bond paper. Single-weight stock, used for production printing in long rolls, is not very good for single-sheet processing. Double-weight stock is about half again the thickness of medium weight and is used for most single-sheet printing. Finally, so-called premium weight is thicker than double-weight stock. Generally, the lighter the stock's weight, the more care needed in handling during and after processing; the heavier the stock's weight, the more expensive the paper.

Printing Speed

Like film, papers have a relative sensitivity to light that determines exposure time. There are three main time divisions: moderately slow, moder-ately fast, and fast. The fastest papers are used in photofinishing labs and generally are too fast for anything but machine or production printers. The slow papers are contact printing papers, used today primarily for printing large format negatives one-to-one; these papers are becoming less and less available. The most common papers are the moderately-fast papers, both in RC and FB types. There are slight differences in speed among moderately-fast papers, but nothing substantial enough to make them criteria for choosing one paper over another.

Contrast

This is the key characteristic in printing papers, because it allows for the greatest image manipulation. By choosing a particular contrast grade, you can enhance or alter the tonal range and contrast of the image when making prints. The term **grade** refers to a step within the contrast printing scale. The scale ranges from #00 to #5, with the lower numbers being "softer" or less contrasty. For example, #00 has no deep blacks, while #5 has virtually no grays, rendering images as black and white.

There are two choices in contrast-graded papers. Fixed-graded papers, which range from #0 to #5 in whole grade steps, are rated at a set contrast grade. Variable-contrast paper has an emulsion formulation that yields different contrasts according to the color of light under which it is exposed. The color of the light is altered by filters, which are called variable-contrast

Contrast grade selection is one of the most important printing controls. Grades can be selected to enhance the mood of the image, to add extra contrast for graphic effects, and to correct for over- or underexposed negatives. Here, the effects of contrast grade selection are shown. The photo (upper left) is contrast grade 2, while the photo (upper right) is contrast grade 4. Similarly, the photo (lower left) is contrast grade 1, while the photo (lower right) is contrast grade 5.

filters, that are placed in the light path during print exposure. With these filters, contrast in half-grade steps from #00 to #5 is available.

With a variable-contrast filter setup, going from a pale yellow to a deep magenta filter yields increasingly higher-contrast grades. If you print on variable-contrast (VC) paper without a filter, it will yield approximately a #2 with a condenser-head enlarger and close to a #3 on a cold-light-head enlarger, though this varies somewhat among brands of paper. (More on enlarger light sources shortly.)

Fixed-graded papers are slowly being replaced in the market by variable-contrast paper. Though purists maintain that the VC papers do not deliver the goods in the extremes (#0, #5), improvements in VC papers have begun to lessen the strength of this argument. The economics of being able to get all contrast grades out of one box of paper can't be argued with, though this printer does keep a box of graded #4 and #5 papers handy.

Contrast grades can be used either to correct a poorly exposed negative to make improved prints, or to make interpretive prints of a full-toned negative. Generally, the aim of exposure is to attain a negative that will make a good print on a #2 contrast grade paper. This is the so-called normal, or standard, by which one judges negatives and image quality.

A #2 paper (or a VC paper printed with a #2 filter) offers the fullest tonal spread and richness of any grade; thus, a tonally rich negative will show its full beauty on a #2 paper. Altering grades from a #2 with a full-tone neg-

ative means that you are trying to lower contrast (by using a #1.5 or lower grade) or to raise the contrast (by using a #2.5 grade or higher) of the image on the print. The greater the difference from a #2, the greater the contrast alteration. Thus, when you alter print contrast when printing a "normal" negative, you are making an interpretive printing choice.

You also alter contrast grade selections to correct for underexposed, contrasty, or otherwise problem negatives. If a negative is underexposed, for example, it may print without any visual "snap" on a #2 contrast; however, you may be able to salvage, and certainly improve, the print by using a #3 grade or higher. Likewise, if a negative is too contrasty or has highlights that are harsh, printing on a lower-contrast grade can help control those harsh highlights and make the print softer, or less contrasty.

While these remedial steps can make a print more visually appealing, there usually is some price to pay in image information, just as there is when you expose film in a way that fails to encompass all the brightness values. For example, when you add contrast to snap up a print, the dark areas will lose some detail. On the other hand, if you opt for softer contrast to control harsh highlights, the black-and-gray areas of the image may begin to weaken or go muddy.

These results can be mitigated somewhat by selective light controls called burning and dodging (which are done when exposing paper under the enlarger), and by a technique

available with VC paper called split-contrast printing. However, as you work you will see that having to constantly correct for film exposure mistakes in printing means you are losing print quality overall and that a quality check on exposure and/or film developing techniques is in order.

Paper Sizes

Most papers come in standard sheet sizes, such as (in inches) 5 x 7, 8 x 10, 11 x 14, and 16 x 20, and are available in quantities ranging from 10 to 250 sheets. More popular papers may also come in smaller sizes, such as 3.5 x 5, as well as other sizes for specialty work, such as 4 x 5, 7 x 10, 20 x 24, and 30 x 40. Of course, you are not limited in image size by the paper size. You can produce 3 x 9.5-inch prints on 8 x 10-inch paper, and so forth.

When you print, you can work **full bleed**, which means the image is printed to the edge of the paper size, or leave a margin around the paper itself. It is usually best to leave some border around the image area, as this allows you to frame and overmat the image later without cutting into the image. This border is a natural result of placing the paper within the blades of the printing easel; the size of the border is determined by how you set those blades.

PRINTING TOOLS

The first step in printing is finding or creating a darkroom space. Darkrooms must be sealed against extraneous, or white, light. They

must also have a power supply, a water supply and drain, a ventilation system, and counter space for the enlarger, timer, and tools. If you don't have space for this in your home, check with a local camera store or camera club about rental or shared darkroom space. Conversion of space in the home to a darkroom does take some commitment, but there are very clever processing systems available that make it less cumbersome than you might think.

Enlargers and Darkroom Tools

The most important piece of equipment for making prints is the **enlarger**. It is a form of projector containing the following: a light source; a way of collecting and distributing light; a stage in which the negative is held so the light can be projected through it; and a lens for focusing and controlling the light. The enlarger must also have a

Darkrooms are the environment in which the magic of photography is performed. Illumination is provided by safelights, to which printing papers are "blind." Home darkrooms require planning, electrical and plumbing fixtures, and a good ventilation system. If you don't have room in your home, inquire at local camera stores about schools or camera clubs that have darkroom spaces for rent.

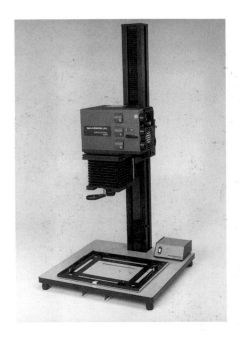

The dichroic head enlarger is intended for color printing but works very well with black-and-white printing as well. You can print with these enlargers using unfiltered "white" light or you can dial in different color combinations to evoke contrast grades when working with variable contrast papers. (Photo: Courtesy Saunders Group.)

rigid support, so that it will not move during print exposure and will project an image evenly to the baseboard.

There are three main types of light sources in general use today. Most enlargers for black-and-white printing are the condenser type. The **condenser head** has an incandescent light source mounted in a cone-shaped head; the light from the head projects down through a series of condensers (glass lenses) through the negative and lens to the printing paper. Condenser heads must be adjusted for different film formats, an easy task that is guided by calibrated rails on the side of the bellows. The adjustable bellows allows you to alter the coverage of the light on the negative stage, thus providing a full circle of light for a variety of negative formats. Failure to adjust for film format will result in light falloff, described as **vignetting**, at the edges of the image.

A **cold light head** (so named because of its bluish light) consists of fluorescent tubes coiled inside a flattened tubular head. A diffusion glass sits right beneath the light source and spreads the light to the negative and lens below. There is no need to adjust for film format when printing with a cold light head. (See Figure 4.1.)

Dichroic heads are used mainly for color enlarging, but they are excellent choices if you do both color and black-and-white enlarging, as you don't have to change heads when going from one type of printing to another. Dichroic heads are composed of two tungsten lamps inside a chamber and some form of filter arrangement through which the lights are projected. The light is mixed in a chamber, then projected down through a diffusion glass to the negative and lens.

Each type of head has its uses and its advocates. Condenser heads yield very sharp and crisp images, but can cause a problem with contrasty negatives. Because of the nature of the light source, highlights may block up or hold back light, and thus print more contrasty than they would appear on the negative.

The two main black-and-white enlarger light sources, or "heads," are of the condenser and cold-light types. Condenser heads work with standard bulbs and pass light through a set of condenser lenses through the negative and lens to the printing paper. The cold-light head works with fluorescent lamps and a diffusion plate, which passes the light through the negative and lens to the paper. Although most printers interchange heads in their work, some are very adamant about which produces the best work for their style of printing.

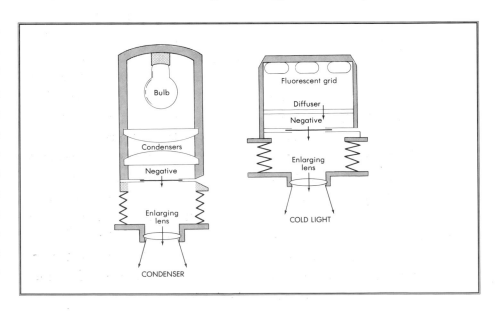

Cold light heads avoid this problem, due to the diffuse nature of the light, and yield the full tonal spread of a negative. In addition, the diffuse light eliminates some dirt and negative defects that may be more apparent on the print if printed with a condenser head. Cold light heads, however, can cause problems with variable-contrast papers, as the bluish light throws off the balance of contrasts evoked when printing through VC filters. You can counter this by placing a yellow filter in the light path, but this generally limits your contrast grade range with most VC papers.

The filter dials on dichroic heads can be calibrated to various VC papers so that no extra filters are required. (Each paper manufacturer publishes charts with grades evoked by filter settings on various dichroic light heads.) However, the tungsten lights are expensive, and the built-in filters can age and fade and must be replaced every so often.

In short, there's no one perfect light source or head. If possible, work with each and get a feel for which best meets your needs. You will quickly see which one best suits your negatives and style of work.

In order to keep negatives in place and flat when enlarging, a **negative carrier** is needed. The carrier has an open frame in the center for the negative and a hinged back that closes to keep the negative in place. Each format with which you work requires a different carrier.

You can use a glass or glassless carrier. Naturally, the glass carrier does keep negatives flatter, but keep-

ing the glass free of dust is an ongoing challenge, and using anything but "anti-Newton ring" glass may result in moiré patterns being projected onto the print. In general, most printers use glass carriers for formats larger than 6 x 7 inches and glassless carriers for 35mm and 6 x 6 cm work. Stopping down the enlarger lens, say from f/5.6 to f/11, creates a greater depth of focus in the projected image, which can eliminate some of the sharpness falloff that less than perfectly flat negatives can cause.

The enlarger lens focuses the image onto the paper, allows for light control through a variable aperture, and gives depth of focus control via those same apertures. The lens used must be matched to the format in use, or light falloff will occur at the print edges. Use at least a 50mm for 35mm film; a 75mm to 135mm lens for medium-format film; and a 135mm lens or longer focal length for large-format film.

In order to hold negatives flat within the enlarger and to mask out stray light from the enlarger light source, a negative carrier is required. In fact, each format with which you work needs its own carrier. (Photo: Courtesy Charles Beseler Company.)

The enlarger lens is used to focus and size the image on the printing paper and to help control the exposure via a built-in variable aperture, just as in a camera lens. Matching the enlarger lens to the negative format with which you work is important. Use at least a 50mm lens for 35mm work, a 75mm to 135mm lens for medium-format work, and a 135mm or longer focal length for large-format printing. (Photo: Courtesy Charles Beseler Company.)

A basic tool in enlarging is an enlarging easel, which keeps paper flat (left) and allows you to adjust borders and cropping via adjustable blades (right). Heavier easels will be steadier on the enlarger baseboard, though nonskid material can be put underneath easels to keep them from slipping while working.

An **enlarging easel** is a hinged frame with adjustable guides used to hold paper flat when printing. Slots on the bed of the easel allow for placement of the paper in the same position for each print. This is necessary so that the focusing and composing stages of enlarging can be done with the confidence that the paper will be in the same position when the print is exposed. The blades of the easel can be adjusted to create various **aspect ratios** (the relationship of height to width) of the image on the paper. These can be slid and locked as needed. When buying or using an easel, work with the next size up from the paper size with which you are working, that is, an 11 x 14-inch easel for 8 x 10 prints; a 16 x 20-inch easel for 11 x 14-inch prints, and so forth.

A contact printer is used to make prints, as well. Unlike the enlarging easel, **contacting printing** is used to create prints the same size as the negative (for large- format work) and for proof sheets from ganged 35mm or 120 negatives. The contact printer is composed of a piece of glass hinged to a flat bed. The best contact frames have heavy glass that will insure snug contact between negative(s) and paper; lacking that, get one with a clamping hinge that will make a tight seal. This is essential for sharpness.

Though you may think that you can focus by eye, the most critical focusing— especially in dense areas of an image—is done with a device called a **grain focuser**. As the name implies, this focuses not on the image or tonal edges within the image, but on the grain of the image itself. Focusing should be performed at the center and at various points around the print. Use of a grain focuser takes some practice, but it is much more reliable than relying on the unaided eye.

A **timer** is key to printing, and a step-and-repeat timer is best for the darkroom. With a step-and-repeat timer, after the exposure time is set and the print is exposed, the timer resets itself to the original set time. Available in both analog and digital readout forms, the timer has two modes—one for focusing and one for the actual enlarging exposure. The focusing mode stays on as long as you need it; the exposure mode stays on for as long as you set the clock. Generally, you plug the enlarger light head into the timer and control the light from the timer itself. Timers can be set in durations ranging from 1/10 second to 1 minute, with some available in 10-minute settings, as well. Repeatable timers are needed to make multiple prints from the same negative and for testing to determine the right print exposure.

Safelights provide illumination in the printing room. The lights are "safe" because black-and-white printing paper is blind to their amber color. If papers are exposed to any stray white light, they will fog (be partially

exposed) or, in the extreme, will turn black upon development. Low levels of safelight illumination, kept at a reasonable distance (more than four feet) for a short period of time, will not adversely affect most printing papers (except very fast papers). Safelights should be used as a general illuminant, near the enlarger table and over or illuminating the processing sink.

The wet side of the darkroom will need trays for processing prints. Use trays one size larger than the print size—8 x 10-inch trays for 5 x 7-inch prints, 11 x 14-inch trays for 8 x 10-inch prints, and so forth. Print tongs are used for moving prints from tray to tray (avoid putting your hands in chemical solutions). There should be one set of tongs for each chemical bath (a minimum of three sets). You will also want a timer (for film processing and some print processing procedures); calibrated beakers for mixing chemistry; a thermometer for checking the temperature of solutions; and a deep print-washing tray or, preferably, a vertical print washer. Other items you will use include a quality squeegee for removing excess liquid from prints; clips for hanging film or prints; and blotter books, sheets, or drying racks for drying prints. Like any craft, printmaking involves its share of gadgets and devices, many of which can be homemade. We will cover some of these as we explore various printmaking techniques.

MAKING PRINTS

Once you have developed your negatives and placed them in protective sleeves, you will naturally be curious as to how the images look as positives. Though you can take the time to print each image individually, the most efficient way to look at your work is with a contact sheet that shows the entire roll of film on one or two sheets of paper. This is a great way to edit and select images for enlargement. It is also excellent for filing, as you can store both the negative sleeve and the contact proof sheet together in a ringed binder. If you work with large format, the contact print will be an instant work print that can also be stored with your negative.

Preparing the Print Chemistry

Before you can print, you must set up developing trays. Like film develop-

Darkroom tools include trays for processing, tongs for handling wet prints, and thermometers for checking solution temperatures. Like any craft, printing involves using many gadgets. (Photo: Courtesy Charles Beseler Company.)

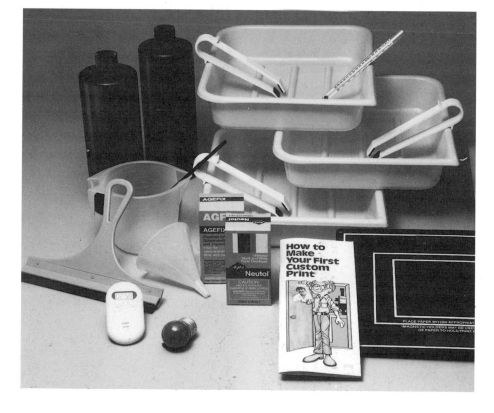

ing, paper developing has three main steps—developer, stop, and fix—followed by washing. The chemicals used in the stop bath and fixer step are the same as those used in film developing. Most printers use the acid stop bath rather than water, but water can be used, albeit at the expense of a quickly exhausted fixer bath. The fixer used in print developing is diluted differently, however, than when used for negative developing. Be certain to read the instructions on the fixer package carefully.

There are a host of print developers from which to choose. The most commonly used today are Kodak Dektol and Selectol, Ilford Multigrade and Universal, and Edwal TST. In addition, there are many other good formulations available right off the shelf. These developers can be used with virtually all types of papers. As mentioned previously, there are warm- and cold-tone developers to enhance or neutralize image color. So-called soft-working developers are used with graded paper supposedly to lower the contrast grade by a half-step. "Ultra-black" developers are designed to produce the richest blacks with whatever papers they develop. There are also variable image color developers that produce different degrees of warmth or coldness, depending upon the dilution at which you mix the developer.

Like all chemistry, print chemistry does reach a point of exhaustion, determined by the number of prints put through (the by-products of development weaken the solution) and oxidation (exposure to air).

Generally, print developer will turn a muddy brown or show some form of precipitant when exhausted (or it simply won't work). Most stop baths have an indicator that turns the solution purple when it needs to be changed. Fixer may show some sign of exhaustion as well, such as precipitant or cloudiness, though not always. The best way to check fixer is with a hypo-checking liquid. Available in a squeeze bottle, you place a few drops in the fixing bath and observe. If these drops turn milky, it's time to dump and mix fresh fix. Some printers use two consecutive fixing baths to ensure proper fixing. We will cover this in more detail shortly when we consider the steps in print processing.

Paper-developing solutions work best at room temperature—about 68 degrees F. Higher-temperature baths are not recommended, though solutions have to get quite warm before they can harm the paper. Temperatures lower than 60 degrees F will slow the process and yield poor prints or, at the least, very weak tones. Lower temperatures are totally ineffective.

Making a Contact Print

All photographic prints are made with the flat, or emulsion, side of the negative facing the emulsion side of the printing paper. Finding the emulsion side of glossy printing paper is easy—it's shinier than the base side. While other papers may be less obvious, the emulsion side generally is "tackier" than the base side. On the

negative, the flat (or emulsion) side is easy to differentiate from the shiny base side. Thus, when you place a negative in the carrier, make sure its shiny side faces up; another way to check is to see that the carrier is placed in the enlarger with the right-reading side of the negative facing up.

To make a contact print, remove the negatives from the protective sleeve and place them emulsion side down onto a piece of #2 printing paper (if using VC paper, insert a #2 filter into the light path) that has been placed on the opened bed of the contact printer. (For contacts, a glossy paper is best: RC paper is the quickest and easiest to process and dry.) Close the glass on top of the negatives and printing paper and, if you have one, clamp the hinge. Before placing your paper and negatives down, defocus the enlarger lens, open it to maximum aperture, and make sure that the projected light covers the entire contact frame area.

The first step is to test to determine the correct exposure time. Set the timer for two seconds and expose the entire print for that time. Then, using an opaque board larger than the contact printing frame, cover 4/5ths of the print and make another 2-second exposure. Make subsequent exposures of 2 seconds each as you move the board about 1/5th of the way across the print with each burst of light. This will give you exposure strips on the print of 4 (2 seconds plus the original 2), 6, 8, 10, and 12 seconds. This is called test strip printing, and we will use it again when we make enlargements.

Remove the paper from the contact frame, being careful to keep the negatives in the same order when you remove them, and place the paper in the developing tray face down. Rock the tray back and forth for a few seconds to insure that the emulsion side of the print becomes saturated with developer. Set the timer for 2 minutes for FB papers and 1 minute (to 1.5 minutes, see paper instructions) for RC papers. Flip the print over with tongs after about 15 seconds and watch the image emerge. Rock the tray every 15 seconds or so to bring fresh developer into contact with the print surface. Do not jab or run the tong ends over the paper surface. This will not help developing and might even damage the print surface. After about 1-1/2 minutes for RC paper (some papers, as mentioned, are made to process faster than that, so check paper instructions) and 2 minutes for FB paper, use the tongs to lift and drain the paper and place it, face down, in the next tray, the short-stop solution.

Prior to making any print, you must test for the proper exposure time. Failure to do so or taking a hit-and-miss approach will waste time and materials. Exposure tests are done with test-strip prints (top) on which a series of exposures are made. After processing and inspection of the test-strip print, a workable exposure for the entire image is determined. The next stage, a work print (bottom), shows where light refinements may be required.

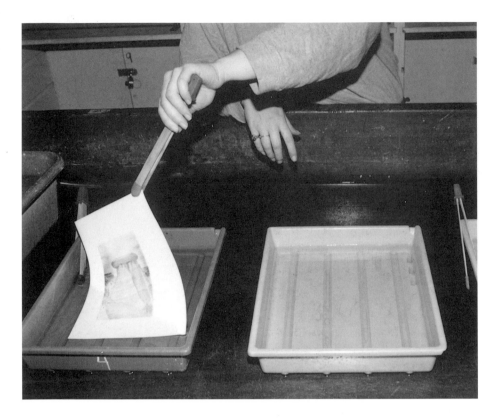

Wet prints should be handled only with tongs. This keeps hands dry and safe from chemicals. Darkroom work entails working dry (at the enlarger), and then wet (at the sink when developing prints). When passing prints from tray to tray, allow them to drip excess liquid prior to placing them into the next bath. This extends the working strength of each bath.

If, while in the developing tray, the image comes up too quickly and all the images turn black (the area on the print not covered by film during exposure will turn black in all cases), remove the print from the tray and, after allowing it to drip dry, throw it away. The blackness occurred because the print received too much exposure. Repeat the test, but this time stop the lens down two stops before doing the next set of test strip exposures.

At the other extreme, if instead the image on that first test sheet does not appear, or comes up weakly (or if the area not covered by film is weak and gray), go back to the enlarger and double your test strip times. Begin with a 4-second exposure and use 4-second light bursts for each subsequent strip. Note that with today's RC papers, if a proof sheet is underexposed at that first exposure

test cycle time with the lens wide open, it may indicate a weak or even contaminated developer. It may also indicate that negatives are much too dense due to gross overexposure or overdevelopment. In that event, recheck your exposure and/or developing technique.

To continue print processing, having placed the print face down in the short-stop solution, rock the tray to soak the print, and keep it in the short stop for about another 30 seconds. Next, pick up the print with the short-stop tongs, drain it, and move the print to the fixing bath, where you will rock the tray as before. After the chemistry manufacturer's recommended fixing time (depending upon whether it's standard or rapid fix, or if you are working with RC or FB paper), use the fix tongs to move the print to the first wash bath. Allow the print to wash in this well-circulating bath for about three minutes, then remove and place the print on the back of a ribless tray or sheet of plexiglass and squeegee off the excess water. Note, however, that this is not the end of the wash cycle. We will inspect the print prior to final washing steps.

Bring the print into white light and inspect it. One of the five test strips may have the correct exposure, or will be very near the correct exposure. That exposure time is the one in which you can "read" the majority of negatives and see a fairly good representation of the images on your film. You may find that some of the frames may be too light (washed out) and some may be too dark, but the majority should be readable pictures. For

the washed-out frames, you can make another proof sheet at a longer exposure time; for the dark frames, you can make another proof sheet at a shorter exposure time.

Once you have selected the correct exposure time, make an exposure of the full contact print with that time. If all the images look harsh or contrasty, however, make another contact sheet with a #1 contrast grade. On the other hand, if all the negatives are weak and lack contrast, make a contact sheet with a #3 or #4 grade. If you deviate from a #2 grade on your contact sheet, make a note with a nonsmudge pencil or pen on the back of the proof sheet after it is dry. This information will be helpful later when you make prints.

Now is a good time to make contacts of the exposure/development test covered in the last chapter. Follow the routine above for making proof sheets, but don't modify your contrast grade to control results. Work with a #2 grade. Select the test strip that is best for average results, then make the whole sheet at that time. Find the optimum negative, and modify your exposure and/or processing according to the procedures discussed in the previous chapter.

Choosing Images for Printing

You now have a positive record of the entire roll of film. Remember to keep the proof sheet with your negative files. While contact sheets are not the best way to judge critical image quality (such as grain and sharpness when enlarged), they do give you a look at composition and allow you to choose one image (frame of film) over another when making prints.

Some printers read contact sheets with a magnifying glass, while others simply scan them and wait until they get the selected negative into the enlarger to make a "no or go" decision. You can also make decisions on how to frame or crop (enlarge select portions of the image) by working with small, L-shaped cardboard pieces. Move these over the image frame to decide on cropping and aspect ratios.

Once you have selected frames, use a red grease pencil to outline those you want. Do not X out the rejects, however, as experience has shown that what may be rejected or overlooked one day can become a vital image the next. Initial instincts are important, but instincts do change.

ENLARGING IMAGES

Some people approach enlarging as a test of their mettle and put too much pressure on themselves to make glorious prints the first time. While this attitude commands respect in some circles, it is not an approach that makes the work much fun. Printing is like any composition, whether words or music. There is a study, then there is a draft, and then there may be an approach at a final effort. Like any composition, photographic prints always go through changes and often are altered according to the whim, or the visual evolution, of the printmaker. There always seems to be room for improvement, or for a change of heart.

Printing is, at minimum, a three-stage process—a test print, a work print, and a final, or refined, print. Ideally, you should be able to arrive at a "working draft," or satisfactory rendition of the image with the expenditure of no more than three sheets of printing paper.

The first stage—the test print—yields the basic information about proper contrast and exposure time, and whether the right paper surface has been chosen for the image. Next comes the work print—the full image printed at the chosen exposure time and contrast and on the chosen paper type. This allows time to contemplate the last stage—the refined print.

Prints are exposed with the same controls as are used with film: the aperture setting of the lens and the exposure time, as determined by the length of time in which the enlarger light is on. In general, the aperture is the constant, set about two clicks, or stops, narrower than maximum aperture, which usually is the sharpest aperture on the lens. Exposure time is the variable. As with film exposure, opening the aperture one stop doubles the exposure, as does doubling exposure time. Conversely, closing down the aperture one stop halves exposure, as does halving exposure time.

Once you have selected an image for printing, open the negative carrier and carefully place the negative in the opening, making sure that the emulsion (flat) side is down (facing the paper) and that the negative doesn't buckle when you close the carrier. Place the carrier in the negative carri-er stage of the enlarger and close the port so it sits firmly and level.

Turn on the focusing light, switch on the timer, and open the lens to its maximum aperture. Place a blank sheet of paper the size on which you want to print within the blades of the enlarging easel. This will be your focusing sheet and will be used each time you print on this size paper. Raise and lower the enlarger head to increase or decrease image size, and align the blades of the easel to create the desired aspect ratio and cropping of your print.

Once you have the correct size and have eyeballed focus, sharpen the image by checking it with the grain focuser. Make fine focusing adjustments as needed, focusing at the center and at the edges. If, despite much effort, you can't get focus both on the edges and in the center, you have an alignment problem with either the negative stage or the head/baseboard. (If this is a gross problem, you must fix this prior to continued printing. Sometimes, a pinch clamp on the negative stage of the enlarger will help keep it flat [particularly with older enlargers]. If it's a severe alignment problem, however, check your enlarger instruction book or query the manufacturer on alignment procedures.) Then, when you do have sharpness, stop the lens down two stops. This will correct minor focusing problems and give you the sharpest aperture of the enlarging lens. Now recheck focus with the grain focuser to insure that nothing has changed.

The next step is to choose a contrast grade. This grade can be selected

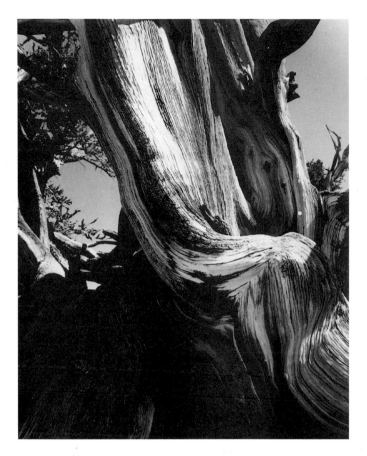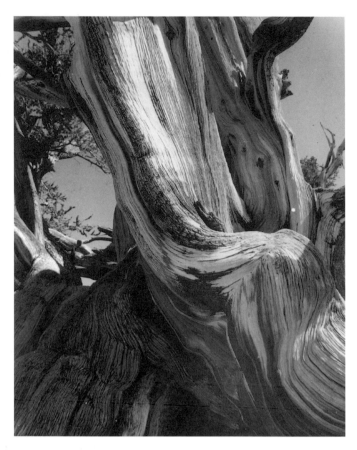

in a number of ways. You may be able to judge from the proof sheet, or you may be able to read the negative itself and make an educated guess. Most experienced printers come very close on the first call. If you are not sure, though, start with a #2. The choice is really rather simple: if you want more contrast than appears in the negative, choose a grade higher than #2, with ever higher grades giving more contrast. If you want to lower contrast, choose a #1 or, if the contrast of the negative is excessive, choose a #0. Then, having selected a grade on which to print the image, either select a graded paper of that number, or use the appropriate filter with VC papers.

Exposure time is determined the same way it's done with contact sheets. Start with an overall expo-sure, say 3 seconds for an 8x10 print. Keep in mind, though, that denser negatives require longer light burst times. Get a minimum of five strips on the test print, which means you will have exposure times ranging from 6 to 18 seconds. Make the test exposures and process the print as described for contact prints.

After fixing, give the print a brief water bath. Take the squeegeed print into white light, or secure your other printing paper and turn on the lights in your darkroom. Do not attempt to judge print quality with the print sitting in the fixer, or illuminated solely by safelight, as this can give a false impression. Look at the overall test print and check the range of exposures. Is any strip close to the correct exposure? If the whole print is too

Contrast adjustment can be used to correct problem exposures or exposure mistakes. Printed on "normal" #2 grade paper, this overexposed negative looks harsh and has lost details (left). However, when printed on variable contrast paper using #0.5 filtration, the contrast problem is solved to a great extent (right). Lowering paper contrast counteracts negatives that are too contrasty. Conversely, underexposed negatives can be given extra snap when printed on higher-contrast grades.

dark, close down the lens and/or shorten the exposure bursts and make another test; however, if none of the strips show information or detail, open up the lens and/or lengthen the burst time.

If the test print looks as if it will yield sufficient information and a range of tonal possibilities, it's time to go through a mental checklist to help determine the right exposure time and contrast grade for the image. First, find the time strip where the exposure seems correct and look at the values within that strip. Are the whites open and clear, or flat and gray? Are the blacks deep and rich, or are they weak and muddy?

If the black and dark values are strong but the whites are harsh, you are working on too high a contrast grade. Instead, use a #1 or 1.5 (if you started on a #2). If the whites are bright and open but the blacks and dark values are weak, you may be working on too soft a contrast grade. Try a step or more higher.

You need not always change grades to attain good prints, though, as interpretive prints often are a matter of changing the density of lightness and darkness rather than contrast grade. However, you should take time to learn how to attain a good straight print—one that manipulates contrast to attain the optimum visual quality. Interpretive prints, in fact, often break the rules of straight printmaking. Frequently, the emotion expressed by these visual statements results from the exact opposite of what would be prescribed by a conventional "print doctor."

Keep in mind that when you go lower than grade #1 and higher than grade #3.5, usually you are doing so to bolster a poor negative, or for emotional effect. When you work in these extremes you are invariably compressing the tonal scale and probably losing some visual information contained in the negative, as well. But if this is necessary, you should do so without hesitation. It is for this reason that VC papers have filters that extend the contrast range of the paper from (theoretically) #00 and #5 grades, and why high-contrast graded papers still sell well. If the negative is underexposed and will print weakly on a normal paper, the best recourse is a higher-contrast paper. If highlights are out of control on the negative, you can get a running start on controlling them by working on a lower-contrast paper.

When doing corrective printing such as this, work with the grade that counterbalances the problem as it appears in the negative. When doing interpretive printing, however, use contrast selection to enhance the mood, but keep in mind that most full-tone negatives display their full range on a #2 contrast grade.

FROM THE WORK PRINT TO THE REFINED PRINT

Once you have settled on a contrast grade and an exposure time, make a full print of the image using the selected exposure time and contrast grade. Process the print as usual, squeegee it off, and inspect it. The work print may seem quite good, or it

may not be totally satisfactory. If the print evokes the latter feeling, think over your choice of contrast and your entire approach to the image. Perhaps it makes a good straight print, but that isn't quite satisfying. Explore other possibilities or put the print aside (after final washing, drying, etc.) to work on another day. Make notes on your procedures so you don't have to retest when you work on the image later.

If the work print seems good, however, then begin to think about the final refinements that will complete your vision. Keep in mind that virtually every printing paper goes through a **dry-down effect**, which means that it gets slightly darker and less contrasty when it dries. That's why test and work prints should be squeegeed prior to inspection. You will get used to the dry-down effect for most of the papers with which you work, but be sure to take it into account when making judgments about work prints and finals. Some printers use a hair dryer after squeegeeing to preview the dry-down effect.

Look next at the highlights and shadows on the work print. They may be rendered nicely, but one area of the principal highlight may be a bit out of control, that is, still too harsh. Look, too, at the significant shadow areas. Are they just right, or could they be lightened up, or perhaps darkened further? Look at the way light flows through the picture. Is it consistent and visually pleasing, or does it need additional refinement?

When you go from the work print to the refined print, you may be adding or subtracting light, thus print density, in selective areas of the image. The idea is to make the print attract the eye. That may mean directing the eye through the control of light; heightening a sense of presence by manipulating tonal relationships; or, perhaps, subtracting detail or visual information from one part of the scene to add dimensionality to another.

Two main printing techniques that accomplish most of these effects are burning in and dodging. (Other techniques, including those using chemicals, will be covered in Chapter 6 on Advanced Printing Techniques.) **Burning in** is the selective addition of exposure, thus density, to specific areas of the print. The converse is **dodging**, or holding back light from select areas of the image during enlargement. Dodging is usually done during the initial exposure. If a large area needs to be dodged, you can make your base exposure the "dodge time" and burn in the rest of the image afterward. Burning in always is done after the initial exposure, as by its nature it is adding light to the initial exposure time. It is accomplished with bursts of light that range from a fraction to multiples of the initial exposure time.

These techniques take some time to master, but the rudiments are easy. For dodging, use pieces of cardboard of various sizes and shapes that are taped to thin wire. Hold back the light from the area to be dodged during exposure by covering the area and moving the shape slightly back and forth. When burning in, allow light to flow through shapes formed by your hands and

Exposure control during printing often requires giving extra exposure time to certain portions of the print—burning in—or holding back exposure from certain portions of the image—dodging. Although you can use cardboard or cutouts as burning in and dodging tools, your hands and fingers can form virtually any shape or form required. By using one or both hands, you can form small spotlight areas when burning in or cover broad horizontal planes when dodging.

fingers, or through shapes cut out in large (larger than the print size, to avoid light spillage) pieces of opaque white cardboard. As with dodging, burn in with a slight motion (feathering) so that tones blend. The advantage of using white cardboard is that you can see the projected image on the top of the cardboard as you work; thus, you can burn in very selectively.

The challenge is in knowing exactly where and how much to burn in or dodge. The work print may reveal obvious areas that need attention, such as burnt-out highlights that need modifying or important subjects that print too dark. But the extent of burning in or dodging to be applied often is determined through testing. Later, experience serves as an excellent guide. For example, there may be times when doubling the initial exposure time for a burn-in is not unusual. At other times it may require a fraction of the initial exposure time. The same applies to dodging, though the main problem here is making sure the tonal areas blend. If a halo of unlike density seems to hover around the subject that is dodged, the technique is flawed. Both techniques require blending, feathering, and practice.

Be aware that the need for burning in is not always obvious. For example, say the subject is a person against a plain background. The lighting is well controlled, and everything seems in balance on the work print. But the subject seems flat and the image lacks dimensionality. Here, adding a touch of burning in to the background and edges of the print shifts the light quality to

create the impression that the face is emerging from a previously monotonous context.

Or there may be a cityscape where the sidewalk seems to be properly exposed, but the work print reveals that the brightness value of the sidewalk fights the rest of the scene for attention. Adding exposure through burning in mutes that value (makes it darker) and allows the viewer's eye more access to the rest of the image. Landscapes and nature photography almost always need similar consideration.

Further, burning in can be used more dramatically to accentuate certain subjects and plunge others into deep shadow. This interpretive approach can be a key to very effective prints. Study the paintings of Rembrandt or the Spanish Village print series of Eugene Smith to gain an appreciation for the masters' use of such techniques. Though obvious or heavy-handed technique should be avoided, don't hesitate to use burning in to serve the image's ends.

Aside from selective burning in, a technique known as **edge burning** can also help bring tonal cohesion to an image. This tends to "close" the image frame and can also help compensate for the almost imperceptible light falloff that may have been caused by the enlarger or negative. Edge burning is done with a straightedged cardboard that is swept into the image from the edges for a fraction of the total print time (say, 1/10 to a maximum of 1/5 the time). As with all burning and dodging, the technique is done with a feathering motion to blend tones.

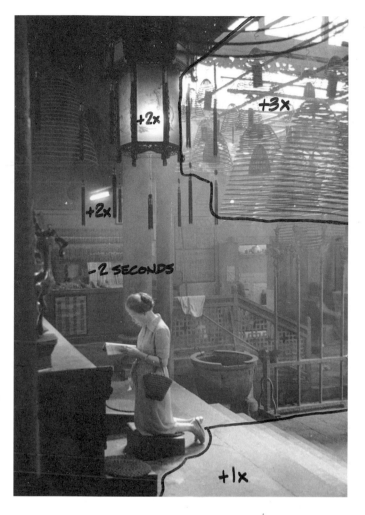

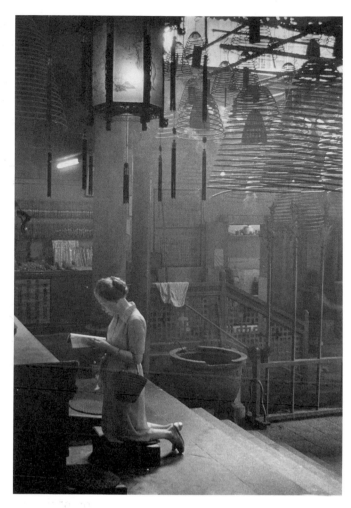

After the work print is done, the need for burning in and dodging may be obvious, or it may require study to see what will make for a refined, final version of the image. Testing and experience will determine the best times. Here, in order to emphasize the fall of light on the subject, edge and side burning was required; to bring out details in the background, some dodging was done (upper left). After cropping the out-of-focus pillar on the left, the overall print exposure was eight seconds. During exposure, the center-left portion was dodged for about two seconds. The stairs leading to the altar were burned in 1X, or another eight seconds. The bright light coming from the ceiling was burned in 3X, or 24 seconds. The lamps were burned in 2X, or 16 seconds each, using a small hole cut in a piece of cardboard. Finally, edges were burned all around to give a feeling of closure to the image (upper right). All burning in was done with a feathering motion to blend the tones; this feathering cuts down overall exposure time by about 10–20 percent for each burn and dodge.

Printing and Processing the Refined Print

The steps between a work print and a refined or finished print may be simple or involved, depending upon your needs and desires. Whatever the steps required, it's a good idea to make notes to guide you through the process, particularly if it is a complex job. For example, your testing may show that the final print will be made on a #3 grade at 9.5 seconds base exposure, with a slight dodge on the shadow area, a 2X burn (thus 19 seconds) on a highlight area, and a 0.5X burn (about 4.5 seconds) on a midtone area, plus a slight edge burn all around.

Note-taking helps when the print is made again later, or as a reference for future printmaking sessions with similar images. Making notes is essential if you are preparing editions of certain prints and want to insure that each image in the set matches the others. (There is no aesthetic reason, however, why you should make a print the same way time after time.)

Once you have done the work on the enlarger, run the paper through the developing cycle as usual. As this will be your final print, however, there are a few more processing steps required to make it a more stable image. These few extra steps are part of what's known as "processing for permanence."

Recall that we took the work print out for inspection right after a brief wash. After that we ran it through the regular processing cycle, which included (after fix) wash, a soak in a hypo-clearing or wash-aid solution, and then a final wash and dry. As for the final prints, we follow the same procedure as for the work print, but add a step that converts the silver in the image to a more stable form. We do this with a toning bath.

Toning baths contain components that bond with the silver to form a compound that is more resistant to the ill effects of pollutants, gases, and other detrimental materials that can stain, bleach, or tarnish the unprotected silver. These toners include those that change the color of the image (to brown, sepia, magenta, and so forth) and those that do the good work without affecting the image color. The most commonly used toner in the latter category is Kodak's Rapid Selenium toner, widely available in liquid concentrate form in photo stores.

After fixing the print, follow with a vigorous five-minute wash, then place the print in a hypo-clearing solution, in which the print should remain for the recommended time, as indicated by the chemistry manufacturer. Afterward, wash the print for five minutes and then place it in a bath of Kodak Rapid Selenium toner, diluted 1:20, for about 1.5 minutes. (To save steps, some printers tone and hypo-clear the print in the same bath.)

Rapid Selenium toner may deepen the blacks and "clear" the whites somewhat in most printing papers; indeed, some papers simply don't show their best without it. At the 1:20 and higher dilutions, the bath should not affect print color. At 1:12 and more concentrated dilutions,

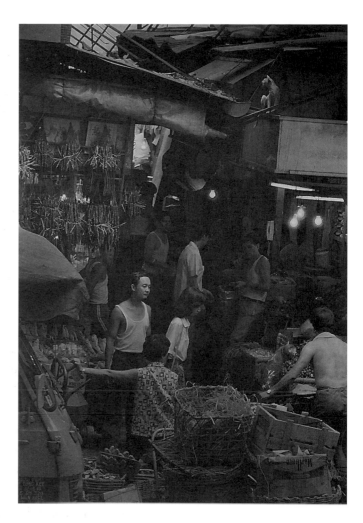

While this negative held a good amount of visual information, the foreground was quite overexposed, and the background sat in shadows, as seen from the single-exposure print made to examine the problem (left). The solution came from contrast control using a variable contrast paper and some select burning in and dodging. The foreground required extra exposure and a lower-contrast grade. The time and grade were determined through testing. The background required a higher-contrast grade and less time, which was also determined through testing. When the print was made, the background was printed first using a #3.5 filter; light was held back from the foreground and top of the print during printing. The foreground and top were then printed using a #1 filter, and light was held back from the background area (right). This technique, known as split-contrast printing, can only be used with variable-contrast printing papers. Edge burns were added to the top and sides of the image to blend the tones and to enclose the subject matter. As a last touch, individual light bulbs were burned in by projecting light through a small hole cut into cardboard.

however, it will give a magenta look to cold-tone papers and a brown-purple look to warm-tone papers.

If clearing and toning baths are separate, always hypo-clear first; after toning, wash the print for about 20 minutes in a vigorous bath. Thorough washing is very important, as it clears residual chemicals from the paper. As mentioned previously, poor washing is the chief cause of poor print stability and later development of stains, so take care to perform the washing step properly.

Just as important as washing for print stability and longevity is careful drying. If working with RC papers, squeegee off excess water and hang them to dry, or lay them flat on a clean, hard surface. If you have an RC dryer, use it.

For FB papers, you have a number of drying choices. Whichever method you choose, make sure your drying materials are clean and free from chemical contamination and stains, because these will transfer to the print during drying and spoil all your work. You also want to keep the prints from curling, which they do naturally, as this may cause cracks, if severe, and at the least will make print handling a chore.

Each printer has his or her own method of drying FB prints. The one you choose will depend upon your needs and space. Lintless blotter books and blotter pages are one proven method. After squeegeeing the prints as dry as possible, interleave them within the blotter pages. When the prints are almost dry, move them to another set of dry pages. Then, when dry to the touch, move the prints to yet another set of dry pages and place an evenly distributed weight atop the stack. If blotter pages become discolored or begin to shed, throw them away.

Print-drying racks, which you can purchase or build, are an excellent option as well, but do require some commitment of space. With racks, paper does not touch paper (as it does with the blotter books), thus there's no chance of lint or other imperfections imbedding into the surface of the print. Racks are stacked close to one another to prevent print curling during drying. Also, as mentioned earlier, racks should be cleaned regularly to avoid chemical staining of the drying prints.

Another drying option, electric dryers are devices that use cloth and heated metal drums or platens to dry prints. Prints are placed between the cloth and metal for a period of time and then removed when the water has evaporated. Place glossy prints face done against the metal and you get a hard sheen; place the face of the prints against the cloth and you get a glossy-dried-matte finish, which is most often preferred. These dryers work well but also must be cleaned regularly to avoid print staining.

Print Spotting

Despite meticulous care, it is almost inevitable that some white spots may show up in the printed image. These spots are caused by dust, tiny hairs, and other foreign matter sitting in the light path (on the lens, condensers, or

the negative itself). They resist light, and thus print as white on the positive image.

After you have been confronted with a few of these on a refined print (on which you have worked for hours), you will do your best to maintain your equipment and to blow off (with pressurized air) any dust from each negative before printing. You will also strive to keep your equipment clean.

Fortunately, however, even after the damage is done, you can apply the technique used for cleaning up the image, called spotting. Prints are spotted (or, better, retouched) with color dyes that match the image color of the paper. The dyes are applied with fine brushes (#000 or finer) so that the density of the dye is ever-so-slightly lighter than the surrounding image density.

Spotting dyes come in common print image colors—neutral, cold, warm, selenium, sepia, and so forth. As we have seen, however, image color can vary quite a bit according to the paper, developer, and toner used. While out-of-the-bottle dyes can work, there are times when it is necessary to mix different dyes to create the proper match. Mixing is done in watercolor palette dishes, with troughs marked for each combination.

Testing mixed color on a print prior to spotting is essential. In fact, using the wrong color dye is almost as bad as leaving the spot untreated. Testing of mixed color is best done with work prints made at the same time as the refined print that requires spotting. Then, after the color is

approved, the spotting can be done using a pecking motion rather than with broad strokes of the brush. This technique relies on building of density; thus, it is better to start slightly lighter than the surrounding density and to add dye as you work.

Work on the spots within the darker tones first, then move to those within the lighter areas as the brush becomes purged of dye. If you have only lighter densities to spot, purge the brush on the work print. If you make a mistake, check the instructions that come with the dye for removal techniques. If necessary, most can be removed with a mild dilution of household ammonia.

Recognize that spotting is an art unto itself. It takes practice and patience to get it right. To achieve the best results, work slowly and lightly, experimenting with a number of work prints first. Take time to match image color and dye; then note the combination on the watercolor palette trough in which you mixed the colors. You can pick up dye from the dried dye patches in the palette by moistening the tip of the spotting brush just before working.

Presenting the Print

The last step in finishing the refined print is making it ready for presentation, or storing it in a way that keeps it from harm. Much study has been done on so-called archival products for print storage. Materials judged to be safe include acid-free papers and boards for mounting, matting, and box storage; certain types of plastic

Despite meticulous care, some spots, formed by dust or other matter resisting light during printing, may form on your prints. Print spotting, or minor retouching, is a tedious affair accomplished with brushes and spotting dyes carefully matched to the image color and density (top). The results, however, are often worth the effort (bottom).

(such as polypropylene) for album pages and negative storage; and baked enamel metal cabinets for overall storage.

These materials share a common attribute—they do not exude gases or contain solvents that can harm photographic materials. Though quite a bit more expensive than ordinary boxes and cardboard, consider the investment as equal to the time and energy you put into making your images. Certainly, not every print you make must be stored in these materials, but quality prints (and negatives, naturally) deserve the finest means of storage. Without it, time and improper care will inevitably result in prints that are dog-eared and damaged.

Print presentation usually means mounting and matting, or simply placing the print in a sleeve or on a board for viewing. Again, archival materials show the proper respect for the work and will be appreciated by those who understand the investment you have made.

When prints are made, a 1/4-inch or more border usually is left around the image area. This allows you to overmat the print (place an overleaf of board that both frames and allows for handling of the image) without covering any of the image area. Overmats can be cut by professional framers, or you can do the work yourself. This author's experience, however, has been that it's best to leave such work to trusted professionals.

Mounting is another matter, though, as it is done with such ease. You can mount prints in one of two ways. Either tape the print to the

backing board with conservator's tape or heat-mount the print to the board via a dry mount press. The former is a simple way to prepare prints for matting, as all it requires is centering and taping at the edges. If prints will not be matted, then dry mounting is best, as the print and board can be presented in a sleeve without having to surround the image with a mat. (The main purpose of a mat is to keep the surface of the framed print from coming into contact with, and perhaps sticking to, the glass.) Do not, however, mount prints that will be used for reproduction, as the mount must usually be removed if the print is to be scanned in the pre-press process.

As with all other framing and matting materials, archival-quality dry mounting tissues are available. They also come in removable and permanent (nonremovable) varieties. Dry-mount presses for photographic prints should have a thermostatic control, as temperature monitoring is crucial. A mounting platen and bed the same size or larger than the prints being mounted make the work easy, though you can mount larger-size prints in sections with smaller presses. There are many manuals and reference guides for dry mounting, so consult these for details.

Having arrived at ways of making good prints, the next stage is to understand how to modify the printing approach to best fit the end use of the image.

Prints are fragile and must be protected from the eager hands of viewers, as well as from the rips and tears that may be caused by careless storage. One of the best protections is mounting the print on a sturdy, acid-free board, which is easily done with a dry-mount press and mounting tissue. When purchasing mounts (or mats), be sure to use archival-quality materials.

PRINTING FOR SPECIFIC PURPOSES

PRINTING FOR SPECIFIC PURPOSES

The end use of the photograph often plays a role in determining the methods and critical decisions that go into making the print. The venue in which the print is reproduced, or viewed, makes certain approaches to printmaking more successful than others. Knowledge about that venue and the conditions it may impose on the print is important. In this chapter we will cover some of those venues and discuss presentation and printing techniques that will generally be most successful.

There can be no single guideline that covers all possible variations of each venue, of course, but asking specific questions and performing research can help to get the best possible results. The goal is to enhance visual communication by understanding how each venue affects the way the image is perceived.

A print is made to be viewed. Whatever you can do to enhance the "life" of that image, to ensure that others enjoy it or find it useful, is part of your task as a photographer and printmaker.

Galleries are the most critical viewing
environments for your prints. Mounting
a gallery show requires a good deal of
time, energy, and expense, but the
rewards of seeing a cohesive body of your
work hung together can make the effort
worthwhile. When making prints for a
gallery, always consider the lighting
under which the prints will be hung.

GALLERY WORK

Perhaps the greatest demands on overall print quality are made in the gallery and collecting world. Those who view the work as curators (people who organize such shows and create a marketplace for photographic images), as well as those who consider the work as art consumers, usually have a high degree of visual sophistication. Thus, they often compare the work they see with the best of what's available.

The gallery world looks at every print for surface flaws and weakness of print tonality. In short, the prints are subjected to a visual fine-tooth comb. Gallery owners and curators view prints as precious and often consider print presentation—the care in mounting and matting, as well as the smoothness and cleanliness of print surface—as a critical element in their evaluation of the work.

Unless the work you intend to show is a retrospective of many years and styles, a cohesive approach to the paper surface, image color, and even mat and mount board consistency may contribute favorably to the overall impression of the work. This is particularly true when showing themes or essays. A highly professional approach, in short, is the only acceptable approach.

This is not meant to imply that the way you prepare work for the gallery needs to be formalized in a narrow way. The environment of the particular gallery and the tastes of its customers will give you the best indication of the type of work that is accepted and expected. The gallery owner or curator may also be helpful in this regard, although he or she usually expects you to have this information prior to showing your work. In addition, the work that is hung on the walls and the photographers the gallery represents also suggest the type of work that would be considered appropriate.

Lighting can be merciless in galleries, though some are lit as dimly as a cozy living room. When the lighting is intense, every flaw in tonality or print finish will be revealed. Thus, extra care is called for in printing, spotting, and preparing the print for framing. Finally, for transporting work to a show, be sure to pack carefully, to insure the work, and to use a shipper familiar with the hazards of handling such items.

While the image itself will guide technique, consider printing somewhat darker (with more density) than usual. You can check the effect of lighting on display by simulating the lighting in the gallery. Once the print is dry, mount it on a wall or tabletop and light it with reflector-mounted bulbs from about six feet away. Use a minimum of 150 watts, although 250-watt bulbs are recommended. This evaluation, which is somewhat extraordinary, will give you a preview of what the print may look like on the gallery wall. While you're at it, take prints you have made in the past and give them the same relentless study. You may be surprised at what is revealed.

Do not use RC prints for gallery work, or as samples of work when

Matting provides a neutral surrounding for print viewing and protects the print from sticking to the glass when inside a frame. This author feels that matting is a craft in itself and is best left to those who practice it; however, many photographers save money by doing their own matting.

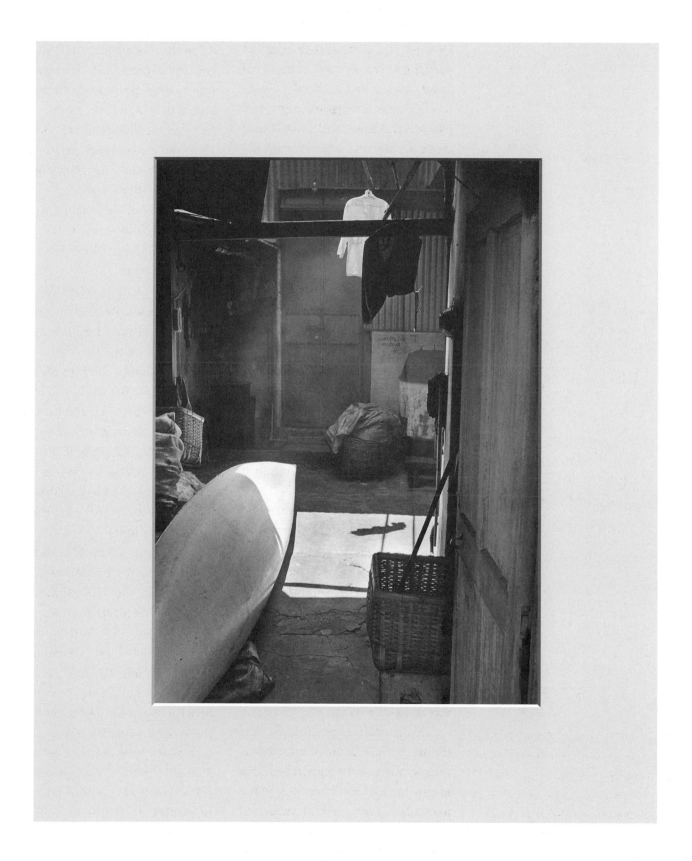

you visit galleries or curators. Fiber-based prints are a requirement. In fact, anything else usually will be met with some disdain from experienced gallery owners and curators. In addition, be sure to process those FB prints for permanence, as this gives the best value to anyone who might purchase your work. Surface choice is subjective, determined by what best serves the image, although glossy-dried-matte (with no hard sheen) usually is preferred.

As mentioned, the manner in which you present your work for review is important. Some galleries will mat and frame the work, or at least take care of the framing, but many places—including libraries, churches, and other nonprofit groups—will not. Therefore, if you are exploring the gallery circuit, make sure that prints are cleanly matted and mounted on proper materials. While mounting and overmatting certainly is less expensive if you do it yourself, working with professional framers can save you time and energy best put into making great prints.

Further, the materials used for print presentation should meet archival-quality standards. While nonarchival materials are cheaper, using anything of inferior quality will not help your chances of getting the work either hung or sold. The frame itself is a personal choice, though most photographers choose metal sectionals or simple wood frames. If you are investing in frames, consider buying one or two standard sizes, then overmatting all your work—regardless of image size—to those standard dimensions. This will save you money and allow you to change prints from frame to frame for different shows without making any further frame investment. Also, though glass does seem to transmit the image better, plexiglass is more practical if your show is traveling with frames, or if you're exhibiting at street art shows.

PORTFOLIO PRINTS

Portfolio prints may be prepared as a group in limited edition sets or used to stock a sample case to show curators, publishing houses, or art directors to attract commercial assignments. The former may be boxed sets covering one theme, while the latter (often dubbed a book) usually is a broader representation of your skills and photographic eye.

Limited Edition Portfolios

While there is no written rule governing it, limited edition portfolio prints generally share production values, and often have images based upon a similar theme. Prints usually are of the same or approximately the same size (certainly the mounts are the same size), and have a common paper surface and image color.

To gain a feel for limited edition portfolios, visit a gallery or museum viewing room and request permission to see portfolios from as wide a range of photographers as possible. The sets themselves usually are contained

in a print box made from archival materials that may or may not be covered in cloth. The front of the box may have the photographer's name and the title of the set embossed on it, and/or a small key image printed as an external front plate. Inside the box, along with the carefully mounted prints you may find an artist's statement and a listing of the prints, as well as other informational matter. Between each print you will usually find a separating sheet of fine paper. Clearly, limited edition sets require a major investment of time, money, and energy. While much of what has been described could be regarded as window dressing, it is, in fact, a statement on the care taken with the images and the thought put into the "merchandising" of the set.

To enhance their appeal and value, limited edition portfolios come in numbered sets. The number of the edition usually appears on the list of prints or on some form of certification, and/or may be found on the lower left-hand corner of the print mount, as well. For example, a number of 11/20 indicates the eleventh set of a limited edition of twenty portfolios. Each print is individually signed and titled (if a title is appropriate). All notations on the print are usually done with a lead pencil. In addition, some photographers emboss, or watermark, the mount in some way. Many photographers also produce what are called artists' proofs (AP), which will be indicated on that portfolio.

When printing, extra care must be taken to maintain consistency from

The presentation of your photographs should reflect the care that was taken in creating them. Portfolio prints often come in numbered limited editions and are presented in archival-quality boxed sets for safekeeping; these boxes are available at art supply stores or from select firms dedicated to working with photographers.

print to print and from edition to edition. This requires applying controls to the variables that affect the look of an image, including the paper stock, developing procedures, toners used, and so forth. Thus, if the limited edition comprises twenty portfolios containing ten prints each, try to get enough paper of the same batch or emulsion number indicated on the paper box itself. Also, use the same developer at a monitored temperature, and carefully note printing controls used (dodging, burning, etc.) on work prints.

As you study the portfolios that appear in museums and galleries, you will see that there usually is little variation among numbered sets. Excellent print quality and consistency within the individual portfolios themselves are part of what is considered a professional approach to the work. Indeed, those who judge, sell, and buy photography tend to be very critical of these aspects. Though the images themselves are most important, paying attention to quality and consistency as well will give you better access to the fine-art photography world.

The Book

A presentation portfolio is a selected group of prints that represents a sampling of your best work. It may be used to gain employment as a teacher or to garner photographic assignments; also, it may be used as a means to attract the attention and interest of galleries, museums, or publishing houses.

Many successful photographers spend much of their free time refining their books, as they clearly understand that their book is their calling card and resume in one. A photographer must demonstrate capability and creativity through his or her book. Thus, the prints selected for the book should express the vision and the skills of the photographer with eloquence.

Photographers generally have a range of prints available for their books and select from that group to create presentations focused toward each potential client. A museum curator may see a book filled with fine art work, while a commercial book may showcase skills in lighting and design. Often, images will be shared among books. This is not meant to imply, however, that you should be a jack of all trades, attempting to please everyone (though many photographers do just that). Rather, it is important to recognize that people will react differently to images, according to their own needs and interests.

Thus, while there are no set rules about books, there is a time and a place for every image. If the aim is to publish work in a gardening magazine, for example, showing careful studies of restored antiques would obviously waste the time of all concerned.

The number of prints you present depends upon the time constraints, the interests, and the needs of the person to whom the work is being presented. If you have fifteen minutes to make your pitch, avoid bringing every print you ever made. Instead, keep your presentation focused.

Sometimes the client or curator prefers a drop-off, in which you leave your portfolio and card at the door and return later to collect the book. In this instance, give the viewers enough images to get them interested, but don't overwhelm them with quantity. It's always best to let quality determine quantity, regardless of the actual number of prints that end up being included. In other words, don't fill a case just to fill it.

Regarding the portfolio case itself, the book portfolio need not be as elaborately produced as the limited edition portfolio. Some photographers invest in leather cases with gold-embossed nameplates, but few curators or art directors dwell on this. Rather, a professional-looking book and individual print presentation done with care will gain favorable attention. In short, show respect for your own work and you will generally be respected by others.

Be certain that all prints in the book are made with the same care as those made for the gallery. This portfolio, however, benefits from a sampling of styles and approaches that displays your diverse abilities and distinguishes your work from that of other photographers. Generally, the images will be viewed quickly (always more quickly than you like) by people who spend a good part of each work week looking at images. As you might guess, an art director with a critical eye will be put off by sloppy work or haphazard presentation. Given that competition for gallery shows and publication is fairly stiff, it's surpris-ing how many people needlessly lose out by failing to take even minimal care in their presentations. Indeed, this is an instance in which attention to details counts.

PRINTS FOR PUBLICATION

There is a wide range of publication venues, and each may require a different approach to printing. For example, a print that will reproduce well in a high-end magazine differs from a print that looks best in a newspaper. Whether printing for magazines, newspapers, brochures, or newsletters, factors such as the weight and finish of the publication's paper and the overall inking of the finished product need to be considered. Though you have little control over prepress operations, understanding the printing process and how black-and-white prints reproduce in a wide variety of venues will go a long way toward getting the best results. Increasingly, prints are scanned and digitized prior to going on press, though the older method of making halftones and stripping them into the page negatives prior to burning the plate still is widely practiced. If care is taken when prints are scanned, the press people or even the art director can "tweak" the image—fine-tune its contrast and overall density—to better suit the publication. To a certain extent, this can also be done with the halftone method, though not to the degree available with high-end scanners and computerized imaging. But this does not mean that prepress personnel

necessarily have either the time or the inclination to fix a poorly printed image. As the saying goes, it's "garbage in, garbage out." When applied to images, this means that poor quality will remain poor quality—even if work is done to alleviate problems. In this case the energy goes into troubleshooting, rather than into enhancing the image for reproduction.

The first step in analyzing what you can do to insure the best print quality in repro is to study the publication in which your work will appear. If the paper quality is good and you can see fine detail even in shadow areas of reproductions, you know that a full-toned print will have a good chance of appearing as such on the page. This does not mean that you should print as deeply as you would for gallery prints, however. In fact, the more "open" the print, the better. If the image is to be used as illustration (for visual information and not as a work of fine art), keep the overall print on the light side, avoid very deep shadows, and control highlights carefully. Of course, if the image does not work without being deep or moody, then there will be no sense in altering its character for reproduction.

Invariably, any print that goes to repro passes through a generational (from one form to another) phase. This means that contrast will pick up slightly (or extensively, depending upon the printing) and that tonality will compress (highlights will become grayer or, conversely, wash out; shadows will become somewhat lighter or, conversely,

lose detail). The severity of these dropouts depends upon the quality of reproduction and the venue in which the image is reproduced.

Newspapers probably are the worst culprits, often because of the inconsistent inking of the large press runs and the overall poor quality of the paper. Despite your best efforts, newspaper repro will always cause some frustration. You can help troubleshoot, though, by printing somewhat lighter than you would for a "normal" viewing print and making sure that contrast is held well in check.

Yet there are times when contrast should be increased. Some publications invariably "flatten" the contrast so much that a print you thought would look good in repro turns out like a gray ghost. Commercial and fine-art photographers who work with various printers usually study a publication before making prints and talk to the art director or publisher about how certain types of images print. To achieve the optimal results you hope for, consider doing this as well.

You may have the good fortune of having your black-and-white work printed in duotone, a process that many photographers prefer. The publisher tends to exercise final control over these matters, however, giving you little voice in determining the process. If you do have sway or influence in the printing of your images, lobby for proofs before your images go to press so you can argue for the best quality.

There's nothing more disappointing than working hard on an image for publication, only to see an awful

printed result. If this does happen to your work, recognize that a number of photographers have shared the experience. The best defense against this outcome is to print light, open, and low in overall contrast, and to consult with the art director or picture editor on the best approach before handing in your work.

MODEL HEAD SHOTS, PRODUCT SHOTS, AND PRESS RELEASE PHOTOS

These photos are discussed together because often they are produced in the same manner. Each begins as a master print, which is then copied and mass-produced (a run of a hundred-plus prints is not unusual) in a photofinishing laboratory. These photos are created for large-scale distribution, and, while the master or original print may be done with great care, the final prints are produced in the fastest and cheapest way possible. Most prints for this work are supplied to end users on glossy RC stock. You should check with your client, however, to see whether a matte finish is preferred, as this surface lends itself to retouching more easily.

To promote better quality, understand that the image will be going through a series of generations, with a strong possibility that contrast will increase and that tonality will compress with each generation. Though careful work in each step will minimize such loss, some is inevitable (and with some labs, is exaggerated). In other words, if you begin with a flat, gray, dull image, the end result

will be virtually unusable. On the other hand, a brisk print, in which the highlights are snappy but textured and the print is slightly lighter than usual, will usually stand up well in the final print.

Thus, if you are printing a master of a darkly colored object (such as a dark-gray computer with slightly lighter keypad), your master print should have tones that are a step or two lighter than what you would normally print. Though tonally "incorrect," the master will be going through copy negative, copy print, retouch, reshoot, and final repro stages—all of which will add some contrast and density to the final print. If, however, the subject is light in tone and has reflective highlights (such as silverware), take care to control highlights, because the contrast gain may eliminate details as you move down the image chain.

As this is a mass-produced print, all retouching and handwork (burning and dodging) must be done on the master print (the print from which the copy negative will be made.) Experienced retouchers may also work on the copy negative itself to give it the qualities and refinements that will yield optimum results. Further, sections of the print or negative may be silhouetted, removed, or heavily retouched. Though you may be involved with some stages of this prep work, the lab with which you work or, certainly, the client and the associated art department, usually will make the judgment calls. Does all this imply that the print you supply need not be

of good quality? Definitely not. Though prints can be altered in each stage to improve results, such work is labor-intensive and expensive, and thus may not be done.

COPY PRINTS AND SLIDES

Copy prints are records of master prints made because the original negative is lost; are records of masters on which extensive handwork has been done; or, in the case of copy slides, are made for submission to juried art shows or as grant or admission portfolios. Care must be taken both in the film exposure and printing stages of the copy process, as critical elements of the picture will be lost with poor technique. Fortunately, copying is a simple enough matter when you work with the right tools and follow some basic guidelines.

The most efficient way to make copies is with a copy stand. This device has a baseboard for placing the copy materials; blades for holding the copy flat and in place (magnetized blades and a metal copy board are good choices); and a rigid column fitted with a platform on which a camera can be mounted. Similar to an enlarger (in fact, some enlarger columns can be adapted to copy-stand work), the copy stand is a tabletop device designed so that the camera (that is, the film plane) and the flat art to be copied are parallel, thus preventing **keystoning,** or the loss of parallelism (and thus the appearance of convergence of the lines) or of the edges in the copied print. Failure to keep the film plane

When making copies, bracket exposures for insurance. This is also an excellent idea when making copy slides, as you can use the darker of the set for projection, the middle exposure for submission to juried shows, and the lighter exposure for reproduction. The bracket here is in 1/2-stop steps.

and copy work parallel may also result in fuzzy edges, especially when shooting at wide apertures.

Many copy-stand setups have brackets on which reflectors and lights can be mounted. Brackets usually are adjustable, so that the lights can be aimed to shine on the copy from a 45-degree angle. This prevents reflections and hot spots from bouncing off the print surface and recording on film. Lights should be kept a minimum of three feet from the material being copied. However, lacking a copy stand, you can mount the print on a wall and mount your camera on a tripod in front of it. Make sure that the copy and film plane are parallel, and mount lights on stands at the same 45-degree angle as used with the copy stand. With both copy systems, make sure the lens is aimed at the center of the print (at the axis of the height and width).

Exposure readings should be made from both the center and the edges of the print with an 18-percent **gray card** (available in photo stores). The gray card eliminates false readings caused by light or dark prints. Making readings from various points around the copy board surface insures that illumination is even from edge to edge. Expose using f/8 (or the middle aperture on the lens— usually the sharpest aperture) and whatever shutter speed is recommended by your meter. If possible, bracket exposures by +/- 1 stop for insurance. Finally, use a cable release to reduce camera vibration.

A low-speed film will yield the finest grain and sharpness (and a

slight edge in contrast). Try Kodak Commercial Film with large format cameras, and any manufacturer's film at or under ISO 100 speed for other formats. Keep in mind that the larger the format used, the better the final result. If you are copying old prints, such as those from the family album, a yellow filter will lighten (or eliminate, in some cases) any yellow stains that may have formed on the print due to age or poor storage conditions.

Some generational loss will occur when making prints from copy negatives. You can minimize that loss by running exposure/development tests on the film. The look of negatives made from copies is slightly different from those made in nature, because you are dealing with reproduction from a piece of paper (with its already-compressed tonality), rather than from the full range of brightness values available.

In general, copy negatives must walk a fine line between retaining all the values in the original and having just enough contrast and density so that the need to use extreme contrast grades in printing (which will compress tonality even more) is eliminated. If, for example, you find that in order to get a decent print from your copy negatives you have to use a #3 contrast grade, consider adding density through either longer exposure times (add a stop) or slightly longer developing times. Conversely, if you have to resort to a #1 contrast grade to control highlights on your copies (this probably will result in flat, dull prints overall), cut back on developing time or try less exposure. As

always, testing is key to finding this balance. Once you find the right combination of exposure and development, stick with it, as copying should be a mechanical, noninterpretive procedure. Inconsistent technique will be a waste of time, because you will soon find that you have less room to fine-tune prints from copy negatives.

Again, the surface and paper on which you print copies is determined by the end use of the image. While glossy stock will give the finest detail, choose matte or semimatte if you plan to do any retouching or hand-coloring on the print later. These surfaces are much more amenable to aftertreatments, such as pencil retouching and oil coloring. Also, consider toning copies of antique prints. This step (see Chapter 7) lends a nostalgic feeling to old pictures, especially those from the family album.

For slide copies, some photographers use a color slide film, such as Kodak Ektachrome Tungsten 64. This film works well with toned images or those that have been hand colored, but may yield an unwanted color cast to copies of untoned black-and-white prints. Use tungsten-balanced color slide film with tungsten light (3200-degrees K) and a daylight-balanced color slide film when using daylight-balanced (5500-degrees K) copy lights, or when shooting copies using daylight.

There are two good choices for making copy slides of prints done on untoned or uncolored modern black-and-white papers: Kodak's Direct Positive Film Developing outfit, used in conjunction with Kodak T-Max 100 film (a do-it-yourself project), and Agfa's Scala Black-and-White slide film, developed only by select custom labs.

When making copy slides, it's wise to bracket +/- 1/2 stop to insure the best results. Though this may produce subtle differences, it can be a critical factor in obtaining exacting exposures. Keep in mind that slides are viewed via transmitted—not reflected—light. Experience shows that a slightly denser image (somewhat underexposed slides) is best when slides will be projected. For repro, a slightly lighter black-and-white slide (+1/2 stop) often is best. It is for this reason that bracketing is important, as you will have a slide for each type of viewing venue.

Having considered some pragmatic examples of exposure, development, and printing, we will turn our attention in the next chapter to some techniques that can be used in the darkroom to create a highly expressive or emotional interpretation of an image.

CHAPTER 6

ADVANCED PRINTING
TECHNIQUES

ADVANCED PRINTING TECHNIQUES

 The advent of computerized imaging has opened up new doors to visual expression. Images can be scanned and manipulated almost without limit and then output on a variety of media. While the novelty of this method is intriguing, black-and-white printers have been exploring image manipulation for many years. Computer manipulation acts upon pixels—the building block of the digitized image; black-and-white printers work with silver and with its alterations when acted upon by light and various chemicals. While the computer changes the character of the image by rebuilding it and then printing it out onto a receiving paper, the image work created by black-and-white printers most often is done on the master print itself.

In this chapter we will explore some black-and-white printing techniques and apply them to various types of images. As with all creative departures, manipulation done for its own sake may be interesting, but the true test of any applied technique is whether it serves the image. The goal should always be to use technique to enhance the communication of the photographer.

Communicating a sense of presence or making an emotional statement in your prints may require you to try a number of visual techniques in their presentation. When an image strikes you as "true," or as defining your special way of seeing, then that technique is "right," regardless of how it may deviate from standard printing techniques. Here, a slight diffusion was added during printing to add a visual edge to the final print. When compared with a "straight" print from the same image, this interpretation evoked a deeper response within me.

This photograph was originally made on conventional panchromatic film and then copied onto an orthochromatic film normally used for photographing documents and line art. This film was developed in a conventional (rather than high-contrast) developer, so that, while contrast was increased, some of the gray-scale values were retained. Finally, the image was made on a #5 grade paper.

HIGH-CONTRAST PRINTING

High-contrast printing involves eliminating or subduing the middle tonal values, thus producing an image in which the visual information is communicated in tones of black and white. High contrast can be used to make near line-drawing renditions or to create highly graphic interpretations of a scene. As it mutes information in the middle values, it accentuates the lines and forms that define the subject.

Virtually every negative can be printed in high contrast; critical decisions, however, will limit this technique to certain moods or scenes. Fashion, urban landscapes, portraits, architecture, and winterscapes are the most common types of images on which high-contrast techniques are

applied, but there are many other possibilities, as well.

The simplest way to achieve a high-contrast effect is to work with a high-contrast paper or high-contrast filter when using VC paper, namely, a #5 grade. With most negatives, this choice eliminates many of the middle gray values. Unlike more commonly used grades, such as #2 or #3, grade #5 has a rather narrow exposure latitude, which means that critical testing is key. If exposed too long, the whites will "gray up." Conversely, underexposure may yield a very weak image. (Note that #5 can also be used to correct extremely underexposed negatives, and often will reveal details not seen by the untrained eye.)

If even a #5 grade fails to yield the desired result, use of a "lith" film as

an intermediary will do the trick. Lith (also called ortho) film is available in formats from 35mm up. This film is made for document and line drawing recording; when developed in a special high-contrast developer, no middle gray values will record. You can also use Kodak Tech Pan film developed for high contrast (see film instructions).

You can make an intermediary negative from an original negative or slide. To make it from a slide, all you need do is enlarge or contact print the slide onto the lith film, just as you would make a print. This will create a reversed, or negative image, which you can then use to make a positive print. To make a lith negative from a negative, first enlarge or contact the negative onto the lith film, and then enlarge or contact that positive onto another sheet of lith film, which will create a negative. (All photo imaging, when done on film or paper, goes negative-positive-negative-positive, and so forth. This allows for some interesting image derivations.) Lith film can be processed under red safelight conditions, so you can inspect the negative as it develops to get it just right.

Once the lith negative is created, you can retouch it with dye to eliminate any gray values that may still exist. Keep in mind that when you opaque a negative, that opaqued area will print white. After you're satisfied with the negative, you can print on virtually any grade paper to obtain a high-contrast image, though a #5 will guarantee the best effect.

You can also photograph with a high-contrast film in the camera, though experience shows that working from a full-tone negative and then converting it to a high-contrast one yields the most creative options.

Note that high contrast does not always mean only black and white. There may be an alteration of tonal values to accentuate a "hard" contrast, with some gray values remaining. This is effective for images for which you don't want a line-drawing effect, yet seek the graphic appeal of a higher-than-normal contrast image.

HIGH-KEY PRINTING

High key describes a printing effect in which the so-called high tones of light gray to white are used to create the emotional appeal of the image. In most cases, this requires a negative with little or no deep black or dark gray tones. The use of this effect, of course, is dictated by the scene and the way you expose it.

The best scene for high-key printing is one that has high, bright values but is low in overall contrast. A well-exposed negative is essential. If a negative has large areas of dark or deep values, or is flat and underexposed, high-key will usually be eliminated as a practical printing possibility. The emotional message of high key is one of an ethereal, dreamy mood. Fashion, interiors, textures, still life, and some scenics work wonderfully with a high-key approach.

Given that the negative is suitable, the combination of a low-contrast paper grade (#1 to #0) and slight print underexposure offers the simplest means to attain a high-key effect.

To enhance the feeling of hot sun and sand, this slightly low-contrast but full-valued negative was printed with 20 percent less time than normal on variable-contrast paper using a #0.5 filter.

Print underexposure may result in some loss of image information and highlight texture, but that's often part of the design.

Finally, don't be afraid to allow some values to go "paper white" in a high-key print, but be aware of any tonal imbalances that may result. After all, high-key printing exudes mood and lends itself to experimenting and bending of some traditional rules. To further enhance high-key images, turn to the section on diffusion printing at the end of this chapter.

LOW-KEY PRINTING

Although it falls within the same family as high-key printing, the approach to tones and the mood that **low-key** printing conveys are totally different. Low-key printing works within the darker portions of the gray scale, relying on the family of tones that

Low-key printing aims to emphasize the beauty of tonal values in the darker portions of the gray scale and does so with the use of low-contrast papers and normal-to-low-contrast negatives printed slightly darker than usual. However, prints should not be so dark that mood overwhelms subject matter. The aim is to bring a sense of mystery to the image.

ranges from middle gray to black as its visual environment. As for high-key printing, negative contrast should be fairly low to begin with, though here bright values or highlights will disrupt the mood.

Low-key images impart a mysterious, often melodramatic feel, thus subject matter and printing approach should match these moods. The forest floor under a canopy of trees, city streets, abstractions from nature, and even portraiture are just some of the low-key printing subjects to explore.

Remember, though, that just because the best negatives for this purpose are low in overall contrast doesn't mean that they should lack detail and vibrancy. True, an under-exposed negative can be printed darker than normal to attain this mysterious mood, and this will yield a good portion of what's called "negative space" (dark areas with no

Printing may involve decisions about what to reveal to and what to hide from the viewer. Here, to add graphic impact and emphasize the gracefulness of the fern, all details except the center portion of the image were given a high-burn treatment. The first print (top) shows the "straight" rendition. In the next stage, the design was enhanced by printing on a high-contrast (#4) grade, thus eliminating some of the details, and by doing an edge burn around the center of the image (center). To bring the image to its conclusion, virtually all the detail around the center was subjected to high burn (about 5X the original exposure time) so that only the two fronds of the fern emerge (bottom).

detail). But the richest prints result from well-exposed negatives printed somewhat darker than normal on a low-contrast paper. This choice will deemphasize any contrast that exists in the negative and yield the appropriate mood without sacrificing print quality and image detail.

HIGH BURN

This technique relies a good deal on your ability to visualize and then create a potentially powerful print from a fairly straightforward negative. The term **high burn** refers to the almost total elimination of a portion of the visual information through the use of selective overexposure (burning in) when printing. This approach works very well with nature abstracts, environmental and candid portraits, and still lifes in which the lighting, or the scene itself, holds dramatic potential.

Under normal circumstances, burning in is used to contour light, to even out tonal areas, to deemphasize edges, and to control selective areas of excessive contrast. High burn requires going many steps further and making critical decisions about just what will and will not be revealed to the viewer. In the process, the image often is transformed into an entirely different scene—one in which the visual spotlight is brought to shine on a hidden form or subject in order to create a new point of view.

Normally, burn-in times might be fractions of the entire exposure time, or multiples of 2X, 3X (or slightly more) at the most. The technique of high burn works more on instinct

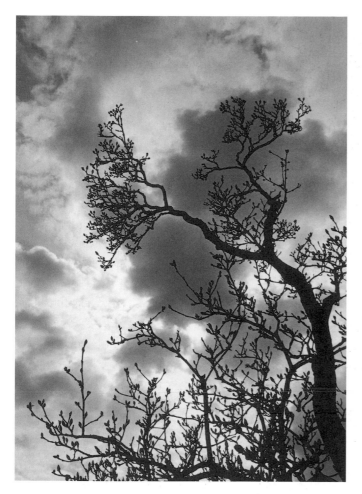

rather than strictly by the clock. After the initial exposure, selective areas getting the high-burn treatment may receive as much as 5X or 10X the exposure time. Indeed, high burn is not a timid approach. It will create black where there was middle gray and begin to add deep, dramatic areas to the print.

PRINTING DOWN

You can manipulate light values in a print just as you can when exposing film. With film, when you expose for the highlight reading (thus record the highlight as middle gray), you drive down the other values into darker tones. Likewise, if you expose for the

highlights when printing, all print values—including the highlight—print darker than on the negative. This approach sometimes is called **printing down**, or saturating the highlights to record close to, or a touch brighter than, middle gray.

You can print down with virtually any negative and on any medium grade of paper (#2 or #3), though a full-toned negative with bright highlights (or one that's even slightly overexposed with "hot" highlights) works best. The trick to this technique is controlling highlight values so that they don't go too dark. Though this may seem a looser type of printing, critical exposure testing is key, as going too dark will lose too

Just as you can manipulate tonal values in film, you have similar choices when making prints. When you expose so that the highlight values in prints are rendered close to middle gray, all the other values are made darker. If you have a full-scale negative with slightly overexposed highlights, this technique can be used to dramatic effect. True, some of the shadow details will be lost in darkness, but this is an emotional, not a "correct," way to print. In these two prints, highlights are treated conventionally (upper left) and then printed down for effect (upper right).

Grain can be enhanced by greatly enlarging a portion of an image and/or by printing on a higher-contrast paper. This image was made from a fairly grainy negative. The first print (top) was made full frame (no cropping) on a #1 grade paper to diminish the appearance of grain. The second print (bottom) was cropped and printed on a #5 grade paper. This enhanced the grain and clearly showed its salt-and-pepper pattern. Though grain such as this is usually considered excessive, the ability to manipulate grain can add graphic appeal to certain images.

many of the lower values altogether.

Printing down is a good way to add mood to nature scenes or portraits in which there is a good spread of values in the negative. It is not recommended, however, if contrast is weak or if the image will lose a lot in the translation.

HIGH GRAIN

This technique assumes you have a grainy image to start with, obtained by using a high-speed, grainy film, infrared film, or by developing the film in a very active developer. Given that, the enhanced appearance of grain in a print is dependent upon two factors—the contrast of the paper and the degree of enlargement of the negative.

To emphasize grain, print on as high a contrast-grade paper as feasible, that is, one that gives strong contrast without sacrificing significant image information. You should recognize that higher-contrast papers in and of themselves are not grainier; the higher contrast merely enhances the texture of the salt-and-pepper pattern of grain in the film. As mentioned, too high a contrast may lose detail in highlights, though some high-grain images sacrifice detail for the sake of the overall graphic effect.

To increase graininess even more, enlarge the image as much as possible. Photographers who specialize in grainy images compose so that the actual picture is in the center of the negative. When they crop to the center, they are using image magnification to further enhance grain. You can also crop as much as possible,

then copy that print onto another film and repeat the process, gaining an even grainier effect.

SPLIT-CONTRAST PRINTING

Variable-contrast paper yields various contrast grades by exposure to different colored light. Expose with light yellow light and a low-contrast image results; expose with a deep magenta light and a high-contrast image results. The full gamut of grades, from #00 through #5, is available. While this allows you to have all grades in one box of paper, it also allows you to print with different contrast grades on the same print.

This technique, called **split-contrast printing**, comes in handy with problem negatives, in which detail may exist in different tonal areas but is difficult to access or express because of contrast imbalances in the recorded scene (see page 89 in Chapter 4). For example, a common problem with landscapes is deep density in the sky area but slight underexposure of the ground portion of the image. This often results from exposure miscalculation or merely from the fact that there was a major difference in brightness values in the two areas.

The first response to this situation might be to bring up detail in the ground area by printing on a #3 grade and to burn in the sky to make up for its greater density. (This is the only way to address these circumstances with fixed graded papers.) This may work, but while the sky is made darker, it may also be too contrasty and should properly be printed on a #1.5

grade for the best rendition. The best solution may be splitting the contrast and working the image as if it were two images—one with greater contrast than the other.

In split-contrast printing, you print one section of the image at a time, beginning with the lower-contrast portion. You test as usual to determine the proper exposure time for each section, then dodge, or hold back light from one section during exposure of the other. You then change filters and expose the higher-contrast section.

This does take some practice, as you must take care not to infringe upon the different contrast areas. Also, you must avoid creating blank or harsh separations between contrast-grade areas. This can be done by blending the light as you work, or by going back and doing some burning in with the lower-contrast filter in place. If you err over borders, do so in favor of the lower-contrast areas.

Practice this technique with various types of scenes with different splits. To ease your testing procedure, keep in mind that most variable-contrast papers have the same printing speed at grades #00 through #3.5, and that grades #4 through #5 usually take exposure increased by half as much for an equivalent density. Check with the paper's spec sheets or instructions to see how the printing speed of the paper you use changes with different contrast-grade selections.

RADICAL CROPPING

You crop an image, or take away part of what's recorded on the nega-

tive, when you make a frame around anything other than the full format of that image. If, for example, you make a full 8 x 10-inch print from a 35mm negative, you will necessarily be cropping the edges of the image to make it fit. Generally, cropping is regarded as refining what you first saw in the viewfinder, or compensating for having the wrong focal-length lens on the camera when you photographed the scene.

Radical cropping is working an image so that it is essentially changed from your first impression. It may be done to emphasize grain, as discussed previously in this chapter, or to force the viewer's eye to contemplate the scene in a unique way. In many cases this is done by changing the aspect ratio of the negative-to-print considerably, such as printing a 35mm negative (a 2:3 ratio of height to width) in a 1:3 format (a so-called panoramic format).

Radical cropping involves nothing more than altering the adjustable blades on the enlarging easel to fit whatever "mask" or framing you desire. It may even involve cutting odd-shaped masks (such as diamonds or ovals) and printing through them. As with all techniques, allow the form and function to work in harmony.

SABATTIER EFFECT

This is a trick effect discovered by accident, but later adopted by surrealists as a formalized expression. This effect results from the partial reversal of tones (from positive to negative) by way of re-exposure of the print to

There are no rules stating that prints must match the format or even the aspect ratio of conventional papers and frames. One hundred years ago, ovals, diamonds, and even oak leaf frames were all the rage. This is not to suggest a return to those formats, but that certain images might benefit from thinking outside the usual 5 x 7, 8 x 10, 11 x 14 formats. Here, a scene (top) loses some empty ground and sky and becomes a more effective composition (bottom), by choosing a panoramic over a standard printing frame.

light partway through the development process. It is a random effect, and results are unpredictable. Though it works well only with certain images, it is worth trying.

Prior to printing, a 15-watt bulb should be placed in a reflector-type socket that comes with an on/off switch. After normal exposure (some printers choose to underexpose slightly), the print is developed until the first semblance of tones (the darker areas) appears. The print is then taken out of the developer, placed on a flat tray back or plexiglass, and squeegeed. Next, the print is held about four feet from the 15-watt light, which is turned on and off quickly, almost like snapping fingers. Afterward, the print is placed back into the developer and allowed to develop to completion.

The effect will emerge right in the developer, and you can remove the print whenever you like. Stop the process by placing the print into the short stop bath. Do not remove the print, however, if tones look muddy or weak, as this will ruin the potential power of the image. If tones come up too dark, you can always bleach back the entire print later (see Chapter 7, pages 128–131). If the entire print comes up black, however, the re-exposure light was either too bright, too close, or left on too long.

You will notice the effect most strongly at tonal borders, where dark meets light, and in highlights, where edges will form around darker interiors. If you want to enhance the graphic effect further, you can copy the positive and make prints on high-contrast

grade paper, or selectively bleach back (reduce) some areas of image density.

PAPER NEGATIVES

The first positive/negative process in photography used paper negatives that were exposed right in the camera. Though this was quickly abandoned when glass plates became available, the broad forms and somewhat ill-defined details had, and still have, a special charm.

It is easy to emulate the look of images created by those old paper negatives, as well as the style of "art" printing in vogue at the end of the nineteenth century, by using today's printing paper as the negative. You can also refine and even remove tones and details by using retouch pencils and inks. To enhance the image further, burnish or draw in texture and lines by using a lead pencil. Or work a print back and forth, from negative to positive and back again, applying textures or eliminating details with each step.

Paper negatives can be made directly from positives—color or black-and-white slides—as the positive will print negative when enlarged. To make a paper negative from a negative, enlarge the negative onto a sheet of printing paper and then contact print that print to another sheet of printing paper. Always make the paper negative the same size as the final print size you desire, as all paper negative printing is done by contact printing.

Choose paper in the lightest weight you can find for this work,

The Sabattier Effect, commonly known as solarization, reverses tones and creates heavy tonal edges on images. Images with varied tonal areas and a host of textures work best. After exposure and initial development, the print was exposed briefly to white light. This re-exposure step is what yields the often-unpredictable results. Although solarization should be used sparingly, the technique works well with certain images, such as this scene from Mardi Gras (top). The solarized image more closely mirrors the photographer's experience than does the conventional print (bottom).

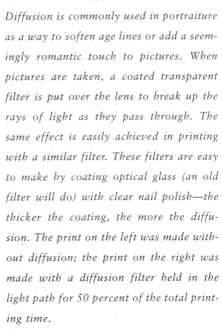

Diffusion is commonly used in portraiture as a way to soften age lines or add a seemingly romantic touch to pictures. When pictures are taken, a coated transparent filter is put over the lens to break up the rays of light as they pass through. The same effect is easily achieved in printing with a similar filter. These filters are easy to make by coating optical glass (an old filter will do) with clear nail polish—the thicker the coating, the more the diffusion. The print on the left was made without diffusion; the print on the right was made with a diffusion filter held in the light path for 50 percent of the total printing time.

since too thick a paper will obscure details and will require overlong exposure times. The best paper available today is a lightweight grade called an "A" weight in the Kodak lexicon. Lacking that, a single-weight matte paper is sufficient. Whatever paper you use, be certain to choose a matte surface, as this allows for easy retouching.

Once you have finished work on the paper negative, place it in a contact printing frame with an unexposed sheet. As usual, you must test printing times. Your final print can, of course, be on any surface and weight paper you desire. You can also do assemblages using paper negatives, taking elements and placing them on the unexposed paper in the contact printing frame. Take care when closing the frame, since the paper can shift easily. Be aware, too, that if you use tape, the texture of the tape (even transparent types) will show up in the final print.

DIFFUSION PRINTING

Just as diffusion filters are used on lenses by portrait and glamour photographers to soften wrinkles and idealize skin textures, printers can use diffusion in the darkroom. This is done by placing a diffusing material in the light path during print exposure. The technique often is used to give portraits a softer look, or to enhance high-key images of any subject by breaking up highlights or point sources of light in the scene.

Diffusion printing can be done with commercially available diffusion filters (the same as used on camera lenses), or by applying Vaseline or clear nail polish to old UV or Skylight 1A filters (or any clear piece of glass) and allowing it to dry. The more you apply, the greater the diffusion effect. In fact, you can use literally any transparent material, as long as it allows image information to pass through.

Diffusion can be used on the entire image or on specific areas by printing selectively. To add diffusion to only part of the image, mount the diffuser in a cardboard mask and expose a portion of the image with it. Burn in the rest of the image later. Further, you can also divide the total exposure time into diffused and nondiffused portions. Different proportions will then yield different effects.

Diffusion is used most often to soften lines and break up highlights. While it is usually applied to high-key images, it can work with virtually any photo regardless of the overall image tone. The goal is to create an image that glows with soft light.

CHAPTER 7

AFTERTREATMENTS: TONING, BLEACHING, AND COLORING

AFTERTREATMENTS: TONING, BLEACHING, AND COLORING

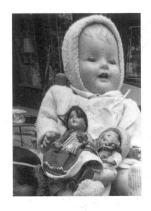

There is a long tradition in photography of using toners, bleach, and coloring oils and dyes to alter prints to enhance their mood or add graphic impact. These options allow you to change image color with toning baths; to enhance highlights, brighten eyes, or clear skies with bleaching; or to colorize the image in any number of illustrative or fanciful ways with oils, pencils, and dyes.

Bleaching, or selective reduction of image density, still is widely practiced among fine art, commercial, fashion, and portrait photographers. Toning as a way of adding mood to an image was widely practiced for the first 100 years of photography, and has since gone through periods of popularity and decline. Regardless of its present popularity rating, it is a very effective visual tool. Coloring has gone through similar periods of revival and decline. Today it is undergoing a very strong renaissance in both the fine art and commercial worlds.

While none of these techniques are necessary to achieve fine print quality or visual excitement in black and white, they are techniques that, when

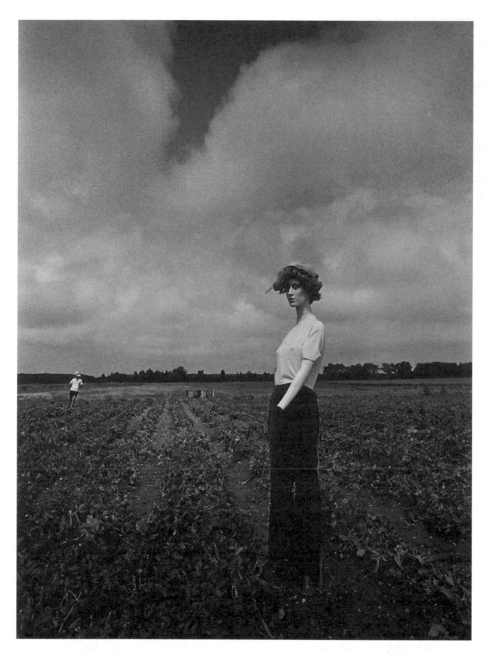

Bleaching, or density reduction, need not be dramatic to be effective. Indeed, in its subtler application it enhances prints that need just a slight visual edge to be successful. In the negative, the subject here did not "jump" from the background as much as desired. Although use of a high-contrast paper might have helped in one way, too much contrast overall would make the print harsh. In order to enhance the contrast, the foreground was burned in, thus darkening the field. After printing and developing, bleach was applied to the mannequin to add contrast and zip to the already startling subject. Bleaching was controlled carefully to avoid eliminating tonality in the subject.

Fashion, model, and portrait photographers have used bleaching as a way of enhancing their lighting for years. Bleaching is also used by landscape photographers to achieve bright clouds or to add sparkle to snow. Here, in a fairly flat photo (top left), a broad stroke of bleach over the model's face yields a brighter look to the photograph (top right).

used properly and with the right image, can expand your options for visual expression.

BLEACHING

Though properly defined as "reduction," since the process reduces image density, **bleaching** is one of the best-kept secrets in printmaking. It is routinely used by custom printers to lighten eyes and gloss lips in portraits; to remove blemishes and hints of wrinkles in celebrity publicity shots; to open up texture in dark fabrics for fashion pictorials; to add brightness to grayed highlights in fine arts prints; to improve skies in

landscapes; and, when used as a bath rather than as a selective application, as a way to salvage prints that may have been printed too dark.

The active ingredient in bleaching is potassium ferricyanide. It is sold in crystalline form in 16-ounce bottles (which will last many years when properly stored) or as Part A in a product known as Kodak Farmer's Reducer. To prepare a working solution mix, dissolve a pinch of potassium ferricyanide in a small tumbler of water. The solution should be very light yellow in color. Too deep a yellow, or a yellow-red solution (as called for in the Farmer's Reducer instructions),

yields a too-active solution that is difficult to control.

The second chemical required is nonhardening fixer—the same as used in print developing. You can also mix the fixer from Part B of the Kodak Farmer's Reducer package. The tools for bleaching include cotton swabs, cotton balls, a squeegee, a fine brush, and a flat tray back or piece of thick plexiglass for a working surface.

Prints can be taken right from the first wash to be bleached, or you can work on prints from previous printing sessions by soaking them in water prior to bleaching. All work can be done in room light; in fact, good illumination is essential to detail work. Be certain to keep hands protected by gloves, eyes protected by goggles or glasses, and the work area well ventilated.

Remove the print from the wash water, place it on the working surface, and squeegee off any pockets of water that may have formed. Dip the applicator (brush or cotton swab, depending upon how fine the detail to be reduced) into the bleaching solution, tap the applicator to remove excess liquid, and cover the area you want to reduce with the liquid. Do not rub in the solution, as application will begin the action. Apply the solution sparingly, because any that runs into another area of the print will cause unwanted bleaching.

After a few seconds the area will begin to lighten. However, if the area lightens immediately and more than you would like, your solution is too strong. In that case, add water to the solution to weaken it. Conversely, if the solution appears to have no effect, it is too weak. To strengthen it, dissolve another pinch of crystals in the bleaching mix. Finally, just before the area attains the density desired, wipe a fixer-soaked cotton swab over it. This will halt the bleaching process.

Squeegee the print and inspect the area. If the tonal value is close to where you want it, place the entire print in a tray of fixer and watch. You will see that the area lightens slightly more. Once you're satisfied with the result, keep the print in the fixer for three to five minutes, then run it through the usual wash, wash aid, and final wash steps.

If, however, the print is not reduced to your satisfaction after the first bleaching attempt (before you place it entirely in the fixer), squeegee off the fixer used as stop and reapply the bleaching solution. Use the fixer again to stop the bleaching action. This process can be repeated as you gradually reduce density in one or more areas of the print. Note that working gradually is critical to success, as this gives you the most control. For example, if you bleach too far back, you may ruin the print by overdoing the effect. Although you can, in select areas, add some density by using dyes, often this is not successful. So work slowly. Once you have achieved the desired results, run the print through the fix and wash steps.

Bleaching usually is most successful in discrete areas of the print, but you can soak an entire print in bleaching solution to reduce overall density,

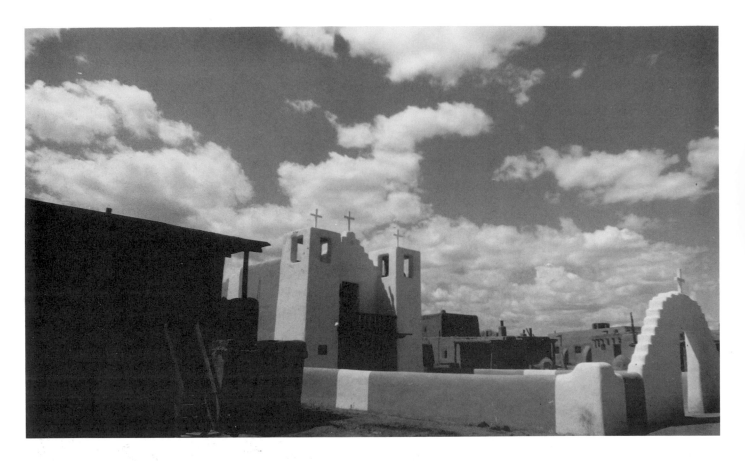

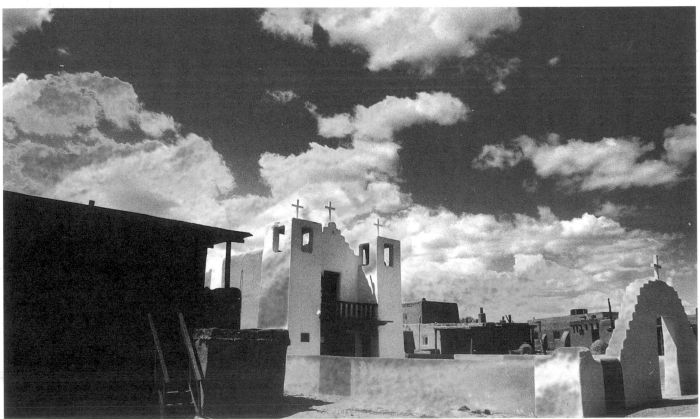

The choice of color toner should be dependent upon the subject matter. Here, the two-bath sepia toner was used to add to the mood of this scene. When sepia toning, print approximately 20 percent darker than normal—this toner "bleaches back" the print during the process.

There are a wide variety of color toners from which to choose, many of which are available in ready-to-use, prepackaged form. You can also mix your own toners using component chemicals. Research in old black-and-white chemistry books (found in used bookstores) will yield these formulae. This scene was toned two ways: the warm brown effect was obtained using Kodak Polytoner, while the blue effect came from Berg's Blue Toner. Both are liquid concentrates that are easy to mix and use.

The colorizing of black-and-white photographs began soon after the invention of photography. While still-life and nature scenes were among the scenes colorized, portraits were the main subjects of the artist's brush and pencil. Studios often employed staffs of hand tinters who studiously added a blush to the cheek or made a full-color rendition of the subject and the surroundings. This nineteenth-century portrait displays the charms of the medium. Today hand coloring enhances subjects in ways that might elude color film.

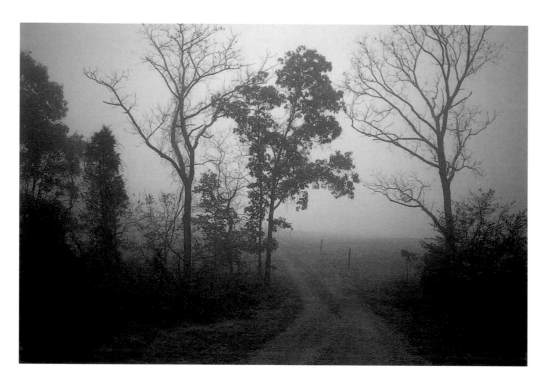

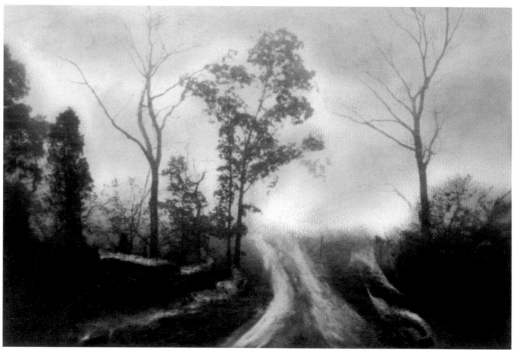

This image is the result of a paper negative process. Starting from a color slide, a black-and-white paper negative was made by enlarging onto a piece of lightweight paper. The paper was then drawn upon with charcoal pencil to opaque areas and highlight certain parts of the scene. A contact print was then made and hand colored.

The artistic license granted by hand coloring allows you to add virtually any emotional effect you desire. The power in these rock faces in New Mexico's Chaco Canyon was first enhanced by making a low-key, somewhat dark print. Color was added to bring a further sense of presence and time to the scene. The direction and power of the light is determined by the print itself, but coloring enhances the somber mood. A lighter "base" print or different color selection might communicate an entirely different feeling.

The delineation and color in this print, though in keeping with the original scene, adds an almost surreal touch to the image. Because of the wide exposure latitude and freedom in printing afforded by black and white, photographing and printing in black and white and then hand coloring allows for interpretations that color film usually cannot provide. The result is a photograph with the greatest possible personal touch. (Photo and hand coloring: Grace Schaub)

Originally photographed on color-slide film, this paper negative print was made by enlarging the slide onto lightweight printing paper, creating outlines and opaquing with charcoal pencil, contact printing the retouched print onto another sheet of paper, and then hand coloring the result. Abstractions are easily made in the darkroom, as you can switch back and forth between positive and negative with each step of the process. (Photo and hand coloring: Grace Schaub)

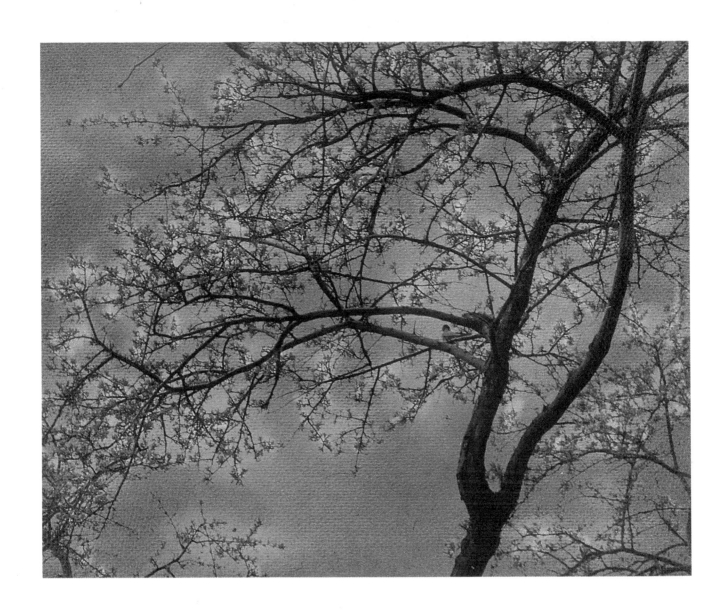

This image was printed on a highly textured paper and then sepia toned. After toning, a wash of color was applied with photo oils. To "clear" the areas around the blossoms, a cotton swab with turpenoid was used. When hand coloring, you needn't always work "within the lines," as the process allows for modification and retouching later.

thus salvaging too-dark prints. Or you can use cotton balls soaked in bleach to work larger areas, such as skies or forests. Be warned that this approach frequently is less successful, however, since the bleach may act unevenly and cause mottling in areas with similar density—a decidedly unattractive result. Although some printers routinely enhance their skies with bleach, whitening clouds and touching up tonal borders with dyes, you should recognize that this technique takes practice to master. Yet once you discover bleaching, it may become a regular part of your final touchup on images. Though not a substitute for careful printing controls, when done right it is virtually transparent to the viewer and can add an exciting visual dimension to your work.

TONING

Toning has both practical and aesthetic uses. On the creative side, it changes image color into a variety of warm browns, blues, and magentas (to name a few) and can add an emotional element to images. On the pragmatic side, toning converts the silver in a print to a more stable compound, thus extending its life expectancy. Toning makes a print "archival," which means that if the print is stored properly out of sunlight and away from noxious fumes and materials, it should easily outlive the photographer—whatever his or her present age.

Before discussing toners, a word about the difference between "true"

toners and colorizing baths is in order. Colorizers are not photographic toners, in that they do not convert—or have elements that bond with—silver. Toners act upon the silver, while dye toners act upon the actual print gelatin, or emulsion, and give a color wash to the entire piece of paper—highlight, edge border, and all. These colorizers, however, can be used to good visual effect, so don't eliminate them from your creative kit. In fact, you can use commercially available colorizers, watercolors, tea, or anything else that will "stain" the print with color.

Each toner yields a range of color effects, depending upon the dilution of the mixed bath and, most important, the type and brand of paper being toned. In general, warm-tone papers take to toning more than neutral or cold-tone papers; that is, the effect of the toner will be more saturated, and thus more dramatic. While cold and neutral papers will change color when toned—some are less affected than others—both show less change than warm-tone papers. As you work with various papers and toners you will note the often subtle differences among papers (warm, neutral, cold); among the same papers when toned in different strength toning baths; and even among prints made from different batches of the same type of paper.

Consider how these differences can affect your methods if you are attempting to create a consistent look in a portfolio or run of prints. You will need to: 1) be sure that all prints are made on the same paper

Bleaching can be used to add a surreal touch to prints. The original scene shows a rich sky and full tones, but it lacks any real sense of drama (opposite top). The second print was made on a higher-contrast paper and was solarized during development. After solarization, many of the areas turned too dark. Bleaching was done on the clouds, the church, and certain portions of the wall. Though rough, the final print is certainly more dramatic than the first (opposite bottom).

and paper stock; 2) insure that developing techniques and solution temperatures are monitored; and 3) mix carefully so that the dilution and strength of the toner are consistent. (Be aware, however, that this strength can be weakened by running too many prints through the toner.) For all these reasons, prints for portfolios often are toned during the same working session.

Toner is quite sensitive to residual fixer left in the print, and failure to fix properly, wash, and hypo-remove with care may result in stains. To get even toning, then, soak prints a few minutes before placing them in the toning bath. Don't stack prints in the toner, and make sure the solution is gently agitated while prints are toning. Do not allow metal surfaces to come into contact with toning solutions, and avoid using metal trays or baked enamel trays with cracks. Any of these could cause staining. Finally, if blue stains form on the print after toning, it may indicate the presence of iron in the water.

Most toners work as single-bath solutions. The print is placed in the bath and toned to the desired hue, then removed. The most common two-bath toner is sepia toner, with the first step being a bleaching bath (a solution of potassium ferricyanide), followed by a sulphide-based redevelopment bath in which the actual toning takes place. With sepia toner, the image actually is bleached back to a light tone in the first bath, then "restored" by redevelopment in the second.

Toners should be mixed according to package instructions, with gloves and protective gear as standard working equipment. Due to their sulphide content, some toners, quite frankly, stink. Aside from being unpleasant, the fumes can be dizzying, so always work in a very well-ventilated area. You can tone in full room light, or even outdoors in the shade.

After any toning bath, wash the print for about twenty minutes in a vigorous water bath. There's no need to hypo clear, as this stage should have been completed prior to toning.

If you tone with sepia or brown toner, or Kodak Polytoner diluted 1:50 (this toner allows for various toning effects with differing dilutions), make prints about 10–20 percent darker than normal, as the toning process bleaches back the image proportionately. Kodak's Rapid Selenium toner (when used at dilutions for either processing for permanence or color toning) tends to intensify the image somewhat (making for deeper blacks and slight clearing of highlights). Some printers underdevelop slightly to compensate for this, though this printer has never seen a full-tone print suffer from this intensification. Indeed, many modern fine-art papers (premium FB) do not show their full brilliance without a Rapid Selenium bath.

Check Figure 7.1 for some ballpark image colors attained by various paper/toner combinations. Old formulary books are filled with interesting and arcane toner formulas for those not content with commercially available types. While chemical components for these toners may be difficult to obtain, and toner results with

modern papers may be questionable, mixing such toners can be interesting. In most cases, such activity will make you appreciate what's available off the shelf.

Finally, keep in mind that the effect of toner on any paper will depend upon the brand and type of paper, the developer used to develop that paper, and the dilution and temperature of the toning bath.

COLORING

The art of hand-coloring, as it is called, goes back to the beginnings of photography. Quite naturally, early photographers sought to add what they considered the enlivening presence of color to monochromatic images. Others did so because the image color of their materials yielded cold and metallic tones, hardly complimentary to their portrait subjects. Still others attempted to emulate the look of the old masters in their print colors.

These pre-color photographers used dyes and toners to add a base or color "wash," over which they used oils, powders, and dyes to add a touch of blush to a cheek or a spot of gold to uniform buttons. Ironically, portrait studios employed the very artists they put out of work to handle the growing hand-coloring trade; landscape photographers painted in skies or dutifully added dots of color to the flowers in their fields.

Hand-coloring has gone in and out of fashion in the last fifty years and still is offered as an added-value service by portrait studios. A revival

Figure 7.1

PAPER / TONER COMBINATIONS

Toner	Effect on Warm-Tone Papers	Effect on Neutral/ Cold-Tone Papers
Kodak Brown	Warm brown	Deep brown
Kodak Polytoner		
1:4	Warm/red-brown	Reddish brown
1:24	Neutral/warm brown	Warm reddish brown
1:50	Chocolate brown	Warm brown
Kodak Rapid Selenium	Reddish brown	Purplish brown
Kodak Sepia	Golden brown	Warm brown
Berg Blue	Blue	Cold blue
Berg Copper	Warm brown to metallic copper (dilution determines)	

in the artistic use of hand-coloring occurred in the 1960s, due to the need for artists to express more than what was offered by color film's palette. After the experimentation came co-optation, and hand-coloring today sits firmly in both the fine art and commercial worlds.

The "hand" part of hand-coloring is perhaps its greatest attraction, in that the application of oils, pencils, pastels, or whatever is a very engaging type of work. While many approach hand-coloring as a sort of fanciful coloring book (in which colors—no matter what the clash—are neatly drawn between the image's lines), others are more playful in their approach.

Photo oils and pencils can be applied to virtually any photographic paper surface, though glossy does require prepping with a "skin" to hold the color. Matte is preferred (RC or FB works fine), as the surface has a built-in tooth to better hold colors. A variety of manufacturers offer retouching

GLOSSARY

Acutance: Edge sharpness.

Agitation: In developing, the physical action of shaking the developing tank to bring fresh developer in contact with film at set times within the developing cycle.

Alignment: The state in which the negative stage on the enlarger and the plane of the enlarging easel are parallel; this ensures edge-to-edge sharpness on the print.

Aperture: The opening in the lens, expressed as f/, which is derived from the relationship between the diameter of the opening and the focal length of the lens. The aperture controls the amount of light coming through the lens, and also determines the depth of field of the image being recorded. Each step in aperture (from, for example, f/8 to f/5.6) equals one stop; each step (thus stop) represents a halving or doubling of light. Higher aperture numbers (f/5.6, f/8, f/11 etc.) represent smaller aperture openings.

Archival: Long-lasting. In processing, those processing procedures that will aid in the stability of the image. Also, storage materials that will not damage photographic film and paper.

Aspect ratio: The relationship of height to width.

Averaging: In metering, the average of the brightness values. For example, if brightness values of f/11 and f/5.6 are read, the average is f/8.

Backlight: A lighting condition in which the light behind the subject is considerably brighter than the light falling on the side of the subject facing the camera.

Bleaching: Reduction of density with a solution of potassium ferricyanide.

Brightness values: The variety of light values within a scene, sometimes called exposure values (EV). The difference between brightness values is measured by an exposure meter. Different brightness values will record as different tonal values, or densities, on film.

Burning in: In printing, the selective addition of exposure to increase density.

Cold light head: An enlarger light source, so named because of its bluish light. The light is emitted from fluorescent tubes through a diffusion glass at the base of the head.

Cold tone: In printing papers, tending toward bluish blacks and clear bright white highlights.

Condenser head: An enlarger light source with a standard incandescent bulb, from which the light is focused onto the negative stage through a set of glass lenses, or condensers.

Contact printing: Prints the same size as the negative made by placing the negative(s) in direct contact with the printing paper in a contact printing frame.

Contrast: The difference in brightness values in a scene. In printing paper, the grades that yield higher or lower image contrast. In film, the way in which tonal values record.

Crop: To print a portion of a full-frame image.

Density: The buildup of silver that creates the image in film and paper.

Depth of field: The zone of sharpness, or apparent sharpness, of subjects within an image from one distance to another. Depth of field is determined by the focal length of the lens, the camera-to-subject distance, and the f/stop in use. The narrower the aperture, the greater the potential depth of field.

Developing tanks: Light-tight containers for developing film in room light.

Developing time: The time in which development takes place; usually refers to the first step in film or paper developing.

Development: The chemical amplification of the latent to a visible image.

Dichroic head: An enlarger light source usually used for color printing, but often used for black and white. The light source is tungsten bulbs that are filtered and reflected down to the negative stage via a light-

mixing box. The color light can be calibrated for use with variable-contrast printing papers.

Dodging: In printing, the selective reduction of exposure, accomplished by holding back the light from certain areas of the print.

Dry-down effect: The normal darkening of a print upon drying. The difference between the brightness values of a print when it is wet and when it is dry.

Edge burning: Adding exposure during printing to the edges of a print in order to emphasize the quality of light in the center of a print or to compensate for any light falloff that might have occurred when printing.

Emulsion: The combination of light-sensitive materials and carrier; another word for light-sensitive materials such as film or paper.

Enlarger: An optical instrument that is used to project images for printing, usually for enlargement of the image to sizes greater than the negative.

Enlarger head: One of a variety of light sources for printing. (See Cold Light, Dichroic Head, Condenser Enlarger.)

Equivalent exposure: Recording the same amount of light; usually refers to shifting aperture and shutter speed values to attain the same exposure. For example, f/11 at 1/125 second is an equivalent exposure to f/5.6 at 1/500 second.

Exposure: In film and paper, the amount of light that strikes the material. Exposure has two controlling elements: aperture, or the opening in the lens, and shutter speed, or the duration of time in which light is allowed to strike the material. A correct exposure is one in which the tonalities and their relationship match those in the original scene; an interpretive exposure is one that records the tonalities and their relationship as desired by the photographer for creative purposes.

Exposure latitude: The range of exposure in which an acceptable image will be produced.

Exposure meter: An instrument used to measure light in a way that translates the brightness of that light to aperture and shutter speed settings.

f-numbers: Aperture settings.

Fast: Relatively more light-sensitive. Refers to high-speed films or printing papers that require less exposure for equivalent density than slower-speed films or papers.

Fiber-based: Print material coated on paper.

Film: The light-sensitive material on which images are recorded. Film is composed of light-sensitive materials suspended in a gelatin emulsion, which is backed by a plastic base.

Filters: For film, controlling color rendition and contrast on black-and-white film by placing various color filters over the lens. To deepen blue skies, for example, use of a yellow, orange, and red filter for deeper blue rendition, respectively. In printing, filters are used to evoke specific contrast grades with variable-contrast paper.

Fixer: The third step in the developing process, in which unexposed silver halides are removed from the film or paper. Rapid fixer is a variation on the common fixing bath, and fixes film or paper in slightly more than half the time.

Fog: Unwanted density that obscures the image or dilutes tonal richness; can result from chemicals, low-level exposure to stray light or, in the case of printing papers, from either too long a time in the developer or overexposure to safelights.

Format: The size of the film, thus the size of the camera that uses such film. Large format refers to sizes 4 x 5-inches and larger; medium format refers to 120-size (6 cm) film and cameras that use such film. An arcane term for 35mm is "miniature" format.

Frame: An individual image on a roll of film; the aspect ratio of the printed image; a picture frame.

Full bleed: Printing to the edges of the printing paper border.

Grades: In printing paper, the measurement of contrast in steps and/or half-steps, with lower numbers being lower in contrast.

Grain: The salt-and-pepper pattern of silver that builds the image. Grain often appears as nonuniform density in areas of the same tone.

Grain focuser: An enlarging aid that magnifies the projected image and allows the printer to focus upon the actual grain of the image rather than the image itself. A critical focusing tool.

Graininess: A subjective term for the visual "noise" caused by grain. Adjectives used to qualify the term are fine, medium, and coarse.

Gray card: A card with 18-percent reflectance; middle gray on the gray scale.

Gray scale: The scale of tones from bright white to deep black, with relative but equal steps of gray (from light to dark) in between.

High burn: In printing, adding more exposure than conventional print-ing procedures would suggest; used for dramatic tonal renditions and graphic effect.

High contrast: In a scene, where the difference in brightness value between the lightest and darker significant values is high. In paper and film, materials that render high-contrast images.

High key: Working in the light gray to bright white tonal range.

Incident meter: A light meter that measures light falling upon the subject.

The meter usually is pointed from the subject toward the camera position.

Infrared film: Film highly sensitive in the red and near-infrared radiation. A red filter is used to block other wavelengths of light when shooting.

Internegative: Formally, a negative produced from positive images (such as a slide) for printing; any negative that is a step in the imaging chain when creating derivations of original images.

ISO number: The film's speed. ISO stands for International Standards Organization. Also used for paper printing speed.

Keystoning: The loss of parallelism or proper alignment of planes due to misalignment of the enlarger (or projector) or lack of perspective control when photographing.

Latent image: The image formed by exposure, prior to development.

Low key: Working in the middle gray to black tonal range.

Negative: An image in which tones, or recorded brightness values, are the reverse of those in the original scene.

Negative carrier: A device for holding the negative in place in the optical path of an enlarger.

Neutral tone: In printing papers, tending toward unbiased blacks and clear bright whites. Neither warm nor cold tone, though the visual impression is closer to cold-tone papers.

Orthochromatic films: Film that is sensitive to UV and blue and green, but is blind to red light.

Overexposure: Too much light has been recorded to faithfully capture the tonal values and their relationship on film or paper. Loss of highlight texture and excessive contrast may result.

Panchromatic film: Film that is sensitive to all colors and must therefore be processed in complete darkness.

Principal highlight: The brightest part of the scene in which texture and image information is to be recorded on the negative or which will print as textured white in the print. When an exposure is made, the highlight used as the basis for exposure to record such information.

Printing down: Exposing a print darker than conventional printing procedures would suggest to achieve dramatic or graphic effects. If the entire print is done in this manner, the highlights are usually printed to about a middle-gray value, with the result that all other values are rendered darker.

Pull processing: Compensating for overexposure by underdevelopment. Often used when scene contrast is beyond the film's normal recording range, as a way of suppressing highlight density buildup.

Push processing: Compensating for underexposure through overdevelopment. Highlights and high middle values gain more density than shadow details in this procedure.

Radical cropping: Printing a small section of an original image to enhance grain or for other graphic effect.

Reciprocity effect (failure of): If a film is exposed at very fast or slow shutter speeds, a certain predictable exposure compensation is required to attain the expected effect of that exposure. Check individual film specifications to see range and factors that need to be applied.

Reflected-light meter: A light meter that measures light reflected off the subject. All in-camera and spot meters are reflected light-type meters.

Resin-coated: Printing paper with a flexible plastic coating.

Resolving power: One measure of a film's ability to record fine detail.

Safelight: A filtered light under which it is safe to expose photographic papers; used as illumination in the darkroom.

Shutter speed: An element of exposure; the duration of exposure.

Significant shadow: The darkest part of a scene in which image information is to be recorded on a negative or which will read as a dark area with image information on a print. When

an exposure is made, the area that is used as the basis of expsosure to record such information.

Silver halide: Silver salt. The light-sensitive material in the film emulsion, formed as crystals, or grains.

Snap: A visual impression of contrast that gives a vivid, fresh feel to the image.

Specular highlight: Light that records as pure tonal brightness on the negative or print, without texture or information. Specular highlights can be found in the light reflecting from water or metal.

Split-contrast printing: With variable contrast paper, the ability to print using two different contrast grades within the same image. The technique is very useful when contrast imbalances exist on the negative that cannot be satisfactorily resolved by burning or dodging on one contrast grade.

Spot meter: A light meter with a narrow angle of acceptance.

Spotting: Correcting blemishes on prints and negatives with dyes.

Stop bath: An acid bath that halts development, thus image formation.

Surface: The texture and sheen of a printing paper.

Timer: The controller of exposure time used with an enlarger.

Tonal scale: The range of brightness values, or that range when recorded on film or paper.

Tone: When used to refer to the gray scale, a step in the graduation from pure black to bright white. When used with papers, to describe the image color. When used as "tonality," or with such phrases as "richness of tone," refers to the character and range of gray scale tones reproduced on film or paper.

Toning: An aftertreatment technique involving chemical baths used to change image color, that also combine with silver to form more stable compounds.

Underexposure: Not enough light has been recorded to faithfully reproduce the brightness values and their relationship on film or paper. Loss of shadow details and compression of the tonal scale may result.

Variable contrast: A type of printing paper in which the emulsion yields a range of contrast grades through the use of different colored lights. Color comes from filters placed in the light path.

Vignetting: The lightening or darkening of the edges of a print. Used pictorially, it is used as a frame within the edges of the image. As a flaw, vignetting can occur when a condenser enlarger is incorrectly set for the format in use or when a lens shade cuts off the edges of the image photographed through a wide-angle lens.

Warm tone: In papers, tending toward brownish blacks and creamy whites. Also, developers that enhance warm tones in printing papers.

Wash aid: A bath that makes fixer more soluble in water, thus reduces washing time on prints and film.

Washed out: Too-thin density; loss of highlight detail.

Weight: The thickness of printing paper.

Zone system: An exposure calculating system based upon dividing the scene into tonal zones, with coordinated exposure/development procedures for gaining maximum tonal values on negatives.

INDEX

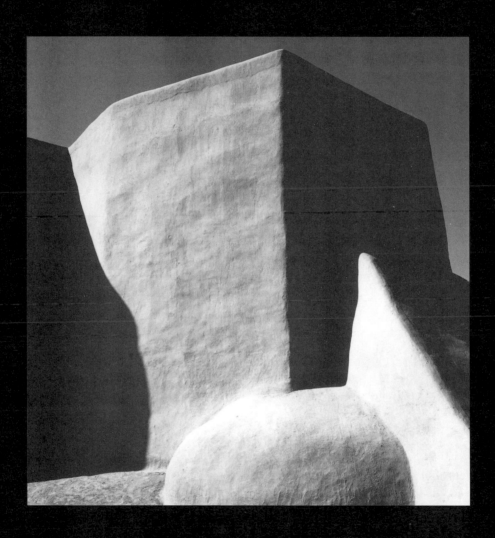